越後妻有
民俗泊物館
ECHIGO-TSUMARI HOMESTAY MUSEUM

ごあいさつ

　「越後妻有民俗泊物館」はちょっと変わった博物館です。越後妻有の里山のお宅に民泊をして、それぞれの生活を調査させていただき、そこからひきだされた現代の民俗資料を収集展示する施設であります。民泊をさせてもらってつくる博物館なので「泊物館」と称しております。

　宿泊者は「みんぱく研究員」となって、越後妻有のお宅に泊まり、それぞれの固有のエピソードを調査していきます。みんぱく研究員は、民泊先のお宅から資料をお借りしたり、伺ったエピソードの収蔵方法を工夫したりしながら、さまざまな民俗資料を収蔵していき、泊物館を充実させていきます。

　越後妻有には、日本有数の豪雪地帯という特徴ある環境の中でさまざまな民俗文化を育んできました。脈々と続いていた生活のありようが、近代化によりこの100年足らずでめまぐるしく変わっていきました。今現在もその真っ只中に私たちは立っています。

　すでに失われてしまったり、なくなりつつあるこの土地固有の民俗文化風習を客観的に調査するのではなく、今生きている人それぞれの営みと関わりながら、近代化、過疎化で揺れ続ける今の民俗文化をみつめていきたいと考えております。

　「越後妻有民俗泊物館」は2015年に開催された大地の芸術祭を機にスタートしたプロジェクトです。十日町市の中心市街地に新しくできた「十日町産業文化発信館 いこて」を拠点に越後妻有全域で展開しました。そして2016年春からは越後妻有里山現代美術館「キナーレ」に拠点を移し、第2シーズンが始動します。

　「越後妻有民俗泊物館」は越後妻有のそれぞれの家の個々の歴史をみつめながら、現代の私たちの民俗について、すこし立ち止まって考えてみる場所です。「越後妻有民俗泊物館」の本館は越後妻有全土に広がっているそれぞれの「家」であり、「集落」であります。「越後妻有民俗泊物館」が越後妻有へのもうひとつの入り口として、今後ともみなさんが越後妻有の中にとびこんでいっていただければ、大変うれしく思います。

深澤孝史
越後妻有民俗泊物館　館長

FOREWORD

Echigo-Tsumari Homestay Museum is a bit different from ordinary museums. The museum researchers stay in different houses in the villages of Echigo-Tsumari, investigating the daily life there. Our museum then displays the information and materials they gathered regarding the modern-day lives of the people of Echigo-Tsumari. Because we use this "homestay (*minpaku* in Japanese)" method of research, we call it "Homestay Museum."

The researchers stay in the homes as guests, documenting the various unique stories of the families who host them. They endeavor to enhance the collection by borrowing materials from the host families and devising ways to archive the stories.

Echigo-Tsumari is one of the regions of heaviest snowfall in Japan. It is in this unique environment that various folk customs have been fostered. However, in less than a century, uninterrupted modernization has rapidly changed the lives of the people in this region. Even now we stand in the middle of this change.

At the Homestay Museum, rather than focus on these unique folk customs that are dying out or have been lost over time, we wish to look at the modern lives of these people and their culture; a folk culture constantly being rocked by modernization and depopulation.

The creation of the Echigo-Tsumari Homestay Museum was prompted by the Echigo-Tsumari Art Triennale 2015. Based at Tokamachi's new downtown addition, the Tokamachi Industry and Crafts Center "Ikote", the Homestay Museum expanded to all parts of the Echigo-Tsumari region. From the spring of 2016, the Museum will be moving to the Echigo-Tsumari Satoyama Museum of Contemporary Art "Kinare" to begin its second season of research.

The Echigo-Tsumari Homestay Museum is a place for us to stop and think about our own folklore in the modern world while reflecting on the individual family histories of the people of Echigo-Tsumari. Nothing would please us more than to have you dive into the world of Echigo-Tsumari through the window that this museum has opened up.

<div style="text-align: right;">

Takafumi Fukasawa
Director, Echigo-Tsumari Homestay Museum

</div>

目次

ごあいさつ ——————————————————— 深澤 孝史 ———— 4
「越後妻有民俗泊物館」のしくみ ——————————————————— 8
民泊調査させていただいた越後妻有の家 ——————————————— 10

資料紹介
一．駒返の家 ———————————————————————— 16
二．中立山の家 ——————————————————————— 22
三．小白倉の家 ——————————————————————— 26
四．湯山の家 ———————————————————————— 34
五．小荒戸の家 ——————————————————————— 42
六．松代の家 ———————————————————————— 50
七．昭和町の家 ——————————————————————— 54
八．姿の家 ————————————————————————— 60
九．田麦の家 ———————————————————————— 68

民泊レポート
①田麦　福崎一久邸（2015年8月1日〜2日）——————— 太田 清美 ———— 82
②小荒戸　五十嵐茂義邸（2015年8月15日〜16日）——— 中田 一会 ———— 86
③昭和町　樋口守雄邸（2015年8月25日〜26日）——— 長津 結一郎 ——— 90

エッセイ
その時間（夕顔の転がり込んだ、）————————————— 谷 竜一 ———— 104
システムとしての深澤孝史、あるいは深澤孝史というシステム ——— 山口 祥平 ———— 105
息継ぎの共有 ——————————————————————— 青木 淳 ———— 106
深澤孝史の美術作法 ———————————————————— 北川 フラム ——— 108

普通の人の博物館 ————————————————————— 深澤 孝史 ———— 118
深澤 孝史 略歴 ——————————————————————— 122
開催概要 ————————————————————————— 124

CONTENTS

Foreword ———————————————————— Takafumi Fukasawa ——— 5
The Process of the Echigo-Tsumari Homestay Museum ————————————— 9
The Host Houses of the Echigo-Tsumari Region ———————————————— 10

Collection
1. Komagaeri House ——————————————————————————— 16
2. Nakatateyama House ————————————————————————— 22
3. Koshirakura House —————————————————————————— 26
4. Yuyama House ———————————————————————————— 34
5. Showa-cho House —————————————————————————— 42
6. Koarato House ———————————————————————————— 50
7. Matsudai House ——————————————————————————— 54
8. Sugata House ———————————————————————————— 60
9. Tamugi House ———————————————————————————— 68

Minpaku Report
1. Kazuhisa Fukuzaki Family, Tamugi, 1-2 Aug. 2015 ———— Kiyomi Ota ——————— 94
2. Shigeyoshi Igarashi Family, Koarato, 15-16 Aug. 2015 ——— Kazue Nakata ————— 97
3. Morio Higuchi Family, Showa-cho, 25-26 Aug. 2015 ——— Yuichiro Nagatsu ———— 100

Essay
Days Before (The bottle gourd rolled in,) ———————— Ryuichi Tani ——————— 110
Takafumi Fukasawa as a System,
or The System Known as Takafumi Fukasawa ————— Shohei Yamaguchi ————— 112
Shared Breath ———————————————————— Jun Aoki ———————— 114
Takafumi Fukasawa's Art Method ——————————— Fram Kitagawa ————— 108

A Museum for the Average Person ———————————— Takafumi Fukasawa ——— 120
Biography ——————————————————————————————— 123
Overview ——————————————————————————————— 126

越後妻有民俗泊物館のしくみ

1. みんぱく研究員に応募する

越後妻有民俗泊物館の公式ウェブサイト（homestaymuseum.net）からみんぱく研究員[※]に応募をします。応募フォーマットに調査希望の家、志望動機などを記入します。応募者多数の場合は館長による選考の末にみんぱく研究員が決定されます。
※越後妻有の里山のお宅に滞在させていただきながら、その家や地域の歴史を調査し、資料を収集する役職です。

2. 民俗泊物館に集合

みんぱく研究員になりましたら越後妻有の中心市街地に位置する民俗泊物館に集合します。そこで館長によるガイダンスを受けます。

3. 民泊先へと出発

広範囲な越後妻有の中心市街地から出発するので、車が必要になってくる場合が多いです。途中の温泉に寄ってから訪問する場合もあります。

4. 民泊調査

民泊先で晩御飯をいただきながら、その土地での暮らしのお話を伺います。研究員ならではの観点をもとにして、どのような資料を集めるかを意識しながら、会話を楽しみましょう。お酒の飲み過ぎにはご注意を。また、集落散策やお祭り、産業の見学など、集落ごとに異なる調査内容が加わっていきます。

5. 資料収集

調査の過程で展示したい資料を決めたら、それらをお借りします。借りることのできないものの場合は模型等をつくります。泊物館では、ものを通してその人がどのように暮らしてきたのかをエピソードごと収蔵していきます。

6. 泊物館に展示

お借りした資料の見せ方を決め、模型等の制作が完了したら、解説を用意し泊物館にいよいよ展示します。来館者に越後妻有での暮らしぶりや、研究員の出会いのエピソードを鑑賞していただきます。このようにして民俗泊物館は、外から訪れる人とさまざまな形で交流し、視点を交差させながら民俗泊物館の充実を図っていきます。

THE PROCESS OF THE ECHIGO-TSUMARI HOMESTAY MUSEUM

1. RESEARCH APPLICATION

You can apply to become a *Minpaku* researcher through the official website (homestaymuseum.net). When applying, please mention your desired location (house), and reasons for applying. In the event that the number of applicants exceeds the needs of the museum, the director will choose, after careful consideration, the applicants who will become researchers.

2. MEETING AT THE HOMESTAY MUSEUM

Those who are chosen to become researchers will gather at the Homestay Museum located in the Echigo-Tsumari city center. The museum director will take the researchers on a tour of the museum and provide them with guidance regarding the homestay houses.

3. DEPARTURE FOR THE HOST HOUSE

As the Echigo-Tsumari region is quite large, you are often required to travel by car. It is sometimes possible to stop at a spa on the way to the house.

4. HOMESTAY INVESTIGATION

The dinner will be your first chance to hear different stories from your host family regarding the region. It is important to enjoy your time there, while staying aware of your duty as a researcher to gather information. Please be careful not to consume too much alcohol. Festivals, gatherings, and work experience are all great opportunities to add different data from each village to the research.

5. COLLECTING EXHIBITION OBJECTS

Once you have decided, based on your research, what you would like to exhibit, you should ask the host family if you can borrow the object. If it cannot be borrowed, then a model should be created. These different objects are exhibited in the museum as examples of how people in the villages live.

6. EXHIBITION IN THE HOMESTAY MUSUM

After you have decided how you will display your object, or its model, it will be exhibited in the museum with a description. Through this object and the story behind it, visitors will be able to appreciate the lifestyle of those living in the Echigo-Tsumari region.

民泊調査させていただいた越後妻有の家
THE HOST HOUSES OF THE ECHIGO-TSUMARI REGION

駒返の家
KOMAGAERI HOUSE

新潟県 津南町 駒返集落

小荒戸の家
KOARATO HOUSE

新潟県 十日町市 小荒戸集落

中立山の家
NAKATATEYAMA HOUSE

新潟県 十日町市 中立山集落

松代の家
MATSUDAI HOUSE

新潟県 十日町市 松代集落

小白倉の家
KOSHIRAKURA HOUSE

新潟県 十日町市 小白倉集落

姿の家
SUGATA HOUSE

新潟県 十日町市 姿集落

湯山の家
YUYAMA HOUSE

新潟県 十日町市 湯山集落

田麦の家
TAMUGI HOUSE

新潟県 十日町市 田麦集落

昭和町の家
SHOWA-CHO HOUSE

新潟県 十日町市 昭和町

Map Labels

- 小白倉の家 / KOSHIRAKURA HOUSE
- 小荒戸の家 / KOARATO HOUSE
- 松代の家 / MATSUDAI HOUSE
- 湯山の家 / YUYAMA HOUSE
- 中立山の家 / NAKATATEYAMA HOUSE
- 駒返の家 / KOMAGAERI HOUSE
- 越後妻有民俗泊物館 / HOMESTAY MUSEUM
- 昭和町の家 / SHOWA-CHO HOUSE
- 姿の家 / SUGATA HOUSE
- 田麦の家 / TAMUGI HOUSE

信濃川 / JR飯山線 / ほくほく線 / 十日町市 / 津南町 / 越後妻有 / 新潟県 / 東京

越後妻有は新潟県の南部、長野県との県境に位置します。十日町市（2005年に旧十日町市、川西町、中里村、松代町、松之山町が合併）と津南町からなる約760km²の地域で、日本有数の豪雪地帯として知られます。信濃川沿岸の河岸段丘と山あいの里山には多くの集落が点在し、約6万5000人が暮らす越後妻有では、2000年から3年ごとに「大地の芸術祭 越後妻有アートトリエンナーレ」を開催。アートによる地域づくりの先進的な事例として世界中から注目を集めています。

Echigo-Tsumari is located in the southern part of Niigata Prefecture, on the border with Nagano Prefecture. The region has an area of about 760 km² and consists of Tokamachi City (five municipalities amalgamated in 2005) and Tsunan Town. Known for its heavy snowfall, the region has a population of 65,000, with many villages scattered throughout the Satoyama landscape. The Echigo-Tsumari Art Triennale has been held every three years since 2000 and has attracted international attention as a pioneering model of regional revitalization through art.

12

13

資料紹介
COLLECTION

駒返の家

津南町の北側、清津川と信濃川の合流地点に位置する集落・駒返。そこに唯一残る茅葺屋根の家。ご主人の石澤今朝松さんは藁工芸の職人でもあり、水力発電所の技師を60歳まで勤め上げた後、津南町の民俗学者・故滝沢秀一氏から民俗学を学ぶ。亡くなった兄は考古学を研究しており、家には文化財指定の縄文時代の石棒や土器などが保管されている。夏の間はアスパラガス農業を行っている。

KOMAGAERI HOUSE

Komagaeri Village is located at the confluence of the Kiyotsu River and Shinano River on the northern side of Tsunan Town.
This is the last remaining thatched roof house in this village. Its owner, Kesamatsu Ishizawa is a straw craft artisan who studied under the late folklorist Hidekazu Takizawa from Tsunan Town after retiring from Shinano River Power Plant at the age of 60. The deceased brother studied archeology, so there are artifacts such as stone bars and earthenware, cultural property from the Jomon Period in this house.

一・駒返の家

信濃川発電所定年後にはじめた藁仕事
THE FIRST TIME WORKING WITH STRAW AFTER RETIRING FROM THE SHINANO RIVER POWER PLANT

調査年月：2015年4月／調査対象：石澤 今朝松（駒返集落）／みんぱく研究員：深澤 孝史
Date: April 2015 / Researched: Kesamatsu Ishizawa, Komagaeri / Researcher: Takafumi Fukasawa

近代化によって失われた豊かさを確かめるための新しい藁仕事

　津南町・駒返集落に住む石澤今朝松さんは、藁工芸を続けて20年以上になる。昔は、藁工芸と農家の暮らしは一体であったが、今は生活の中で藁を使うことは少なくなり、機械化で米の収穫の際、藁を粉砕してしまうことがほとんどだ。今朝松さんは質のよい藁を手に入れ丁寧に保管し、観光の体験道具や、お土産品として家に飾るしめ縄などをつくっているとのことだ。

　今朝松さんは、若い頃から水力発電所の技師として、信濃川水力発電所をはじめ全国各地へと冬の間出稼ぎにいっていた。信濃川発電所は、JR東日本と東京電力のものとがあり、どちらも昭和14年に稼働している。

　定年後、今朝松さんは、近代化で便利になった暮らしの中に、物質的な豊かさだけではない、生業と生活が直接結びついた暮らしを今一度見直そうと、民俗学者の故・滝沢秀一先生に教えを受け、地域の民俗学の研究と藁仕事をはじめた。

　かつては生業だった藁仕事は近代化によって生活から切り離された。しかし今朝松さんは、それでも藁仕事を残そうとする。今朝松さんの藁細工は、見た目はかつてどの農家でも作られていた藁道具と同じでも、今朝松さんの業とでも呼べるような「残そうとする意思」により、別のものに変化しているように思える。

1 – 子ども用の雪帽子をかぶる今朝松さん

BEGINNING STRAW CRAFT TO REAFFIRM THE RICHNESS OF THE LIFESTYLE LOST TO MODERNIZATION

Kesamatsu-san has been working with straw for over 20 years. Previously a craft was part of agricultural life, in modern times straw crafts are usually made as souvenirs, attractions for tourists, and decorative shimenawa, lengths of straw rope used in the Shinto religion.

From when he was young, Kesamatsu-san had been leaving his home every year in the winter to go work at the Shinano River Power Plant and other plants throughout Japan. The Shinano River has two electricity plants, one owned by East Japan Railway Company and the other owned by Tokyo Electric Power Company, both of which began operation in the winter of 1939.

After retirement, he reevaluated his way of life. For him, while materialistic gains played a part in the modernization of the country, they weren't everything. He felt it was important to have a connection between the way we live and the way we make a living. With this in mind, and under the tutelage of folklorist Hidekazu Takizawa, Kesamatsu-san began working with straw.

While straw work used to be an essential job, its connections to modern life have long since been severed. Still, Kesamatsu-san endeavors to pull the craft back from the brink of extinction. On the outside, the work may appear the same as traditional straw crafts, but in Kesamatsu-san's hands, the straw is changed into a totally different form; one could even call it art.

1 - Kesamatsu-san wearing a child's straw headgear for snowy weather

一・駒返の家

床の間の縄文土器
THE JOMON PERIOD POTTERY IN THE TOKONOMA

調査年月：2015年4月／調査対象：石澤 今朝松（駒返集落）／みんぱく研究員：深澤 孝史
Date: April 2015 / Researched: Kesamatsu Ishizawa, Komagaeri / Researcher: Takafumi Fukasawa

　今朝松さんの家の床の間には縄文土器に鬼灯が生けられて飾られている。この縄文土器は今朝松さんの亡くなったお兄さんの寅義さんが発掘したものである。寅義さんは戦争から生きて戻ってきたが、負傷して後遺症が残り長く働ける体ではなくなってしまった。そのうち寅義さんは考古学にのめりこむようになり、他にも重機をつかって重要文化財の大きな祭礼用と思われる石を発掘したこともある。戦争の負傷がたたって、20年以上前に寅義さんは亡くなってしまったが、民俗学という別の分野でその精神は弟に受け継がれることになった。

　今朝松さんは子どもの民泊を受け入れており、縄文土器を見た子どもはついつい触ってみたくなるそうだ。花などを生けていれば子どもたちがいたずらをしないからとはじめたという。人々の営みを大切に思う今朝松さんの家にはいろいろなものが集まってくる。

　In Kesamatsu-san's *tokonoma*, an alcove in Japanese houses for traditional decoration, a Chinese lantern plant can be found displayed in a piece of pottery from the Jomon period. This piece of pottery was originally dug up by Kesamatsu-san's now deceased brother, Torayoshi-san. Kesamatsu-san first started decorating the Jomon pottery with the flower in the hope that it would keep it from falling prey to the mischievous ways of the children who would stay at his house when doing folk studies about the area.

　Many things can be found in the house of Kesamatsu-san, a man who believes in the importance of the way we live our lives.

1 ― 石澤今朝松さんと奥さんのヒサさん
1 ― Kesamatsu Ishizawa and his wife Hisa

一・駒返の家

アスパラガスを収穫するための雪そり
THE SLED FOR THE ASPARAGUS HARVEST

調査年月：2015年5月／調査対象：石澤 今朝松（駒返集落）／みんぱく研究員：深澤 孝史
Date: May 2015 / Researched: Kesamatsu Ishizawa, Komagaeri / Researcher: Takafumi Fukasawa

初夏の間だけアスパラガス農家になる
今朝松さんの収穫方法

　収入源となる農業を地域で模索した結果アスパラガスにたどり着き、石澤今朝松さんは、何十年にわたり夏の間アスパラガス農業を続けてきた。

　今朝松さんのアスパラの収穫方法が興味深い。1日のうち早朝と昼下がりの2回収穫する。カマに目盛りがついており、出荷できる長さになったものだけを刈っていく。収穫したアスパラガスは、腰にまきつけた子ども用の雪そりに積まれていく。

　80歳を越える今朝松さんだが、5月から7月にかけての2ヶ月は雨の日以外は1日も休みはない。

KESAMATSU-SAN'S METHODS FOR THE EARLY SUMMER ASPARAGUS HARVEST

　When searching for a source of agricultural income for the area, asparagus was suggested as a promising crop. Kesamatsu-san has been continuing his summer asparagus harvest for a fair number of years.

　His harvesting methods are quite interesting. He harvests twice a day; once in the morning and once in the early afternoon. His sickle has measured tick marks so that only asparagus spears of the right length are harvested. Harvested spears are thrown into a child's sled that Kesamatsu-san pulls behind him via a string attached to his waist.

　Though he is over 80 years old, he continues this daily harvest for two months straight, May through July, without taking a single day off.

中立山の家

中立山は渋海川の上流に位置している浦田地区の集落。15年ほど前に集落の空き家となった茅葺屋根の民家に移住した木暮茂夫さんが住んでいる。この家は2011年3月の長野県の地震で大きく傾き、全壊扱いされたが、修復をし、今も農業や茅葺職人を営みながら生活をしている。

NAKATATEYAMA HOUSE

Nakatateyama Village is in the Urata District, which is located upstream of the Shibumi River. Shigeo Kogure, the owner of this thatched roof house moved in when it became vacant about 15 years ago. As a result of the Northern Nagano Earthquake in March 2011, it tilted badly to one side and was condemned, but the owner repaired it. He still lives there, farming and working as a *fukikae* craftsman, who rethatches roofs.

二・中立山の家

全壊扱いの中立山の家をなおして住む
LIVING IN A HOUSE ONCE DESTINED FOR DEMOLITION

調査年月：2015年6月／調査対象：木暮 茂夫（中立山集落）／みんぱく研究員：深澤 孝史
Date: June 2015 / Researched: Shigeo Kogure, Nakatateyama / Researcher: Takafumi Fukasawa

　15年ほど前に浦田・中立山の茅葺屋根の古民家に移住した木暮さん。古民家は明治27年に建てられたもので、元の家の主人は昭和の終わりに集落を離れた。木暮さんはその家を借りて修復しながら、茅葺職人と農業をしながら暮らしている。

　2011年3月12日に発生した長野県北部地震により何年もかけて直した家が一瞬で崩れてしまった。せっかく塗った土壁が剥がれ落ち、柱も何本か折れてしまい、大きく斜めに傾いてしまったそうだ。現代の建築基準だと全壊扱いになった家を前にして、なす術を失った木暮さんは途方にくれてしまった。

　被災から3日後、とある友人に「おまいさんの友達100人集まればなんとかなるんでないかい」といわれ、木暮さんは落ち込むのを止め、家を再び修復する決心をした。十日町市に住む宮大工の棟梁に家をみてもらったところ、昔の家は柔構造なので歪んでもひっぱれば元に戻るとお墨付きをもらった。そして多くの支援を受け、中立山の家はもう一度蘇った。

　木暮さんが住み始めた時、家の改装記録ともいえる普請帳が見つかった。見つかった普請帳は明治中期と大正末期の葺き替えの記録だった。

　木暮さんの手で息を吹き返した家の現代の普請帳ともいえるドキュメント映画も上映されたそうだ。2015年、2件目の古民家の修復に取り掛かりはじめた木暮さんは、集落への新たな移住者を募集している。

1− 地震のときに折れた大黒柱に当て木をして修復した ｜2 − 茅葺屋根の葺き替え作業の休憩時間 ｜3 − 木暮邸の居間｜4 − 木暮さんが飼っているヤギ

Over 15 years ago, Kogure-san moved into a thatched roof house in Nakatateyama. However, this house Kogure-san had taken years to fix up was damaged during the Northern Nagano Earthquake in March 2011. The *tsuchikabe*, a Japanese style wattle and daub material used on walls, that Kogure-san took great care in applying, crumbled and fell off. Several of the supporting pillars also snapped, giving the house a terrible slant. Modern architectural procedure deemed the house destined for complete demolition.

Three days after the disaster, Kogure-san was at a complete loss what to do. However, a friend made a suggestion; "If you were to gather around a hundred or so of your friends, I am sure we could do something about the house." This settled the matter, and Kogure-san decided to try to fix the house. Older houses were built with very flexible frames. All one needs to do to fix a tilt is to pull it in the right direction, and this will set everything straight. This is what Kogure-san did, and the straightened house is still lived in today.

A notebook documenting the construction of the house was discovered at the time when Kogure-san first moved in. It records the rethatching of the house from the late 19th century up to about the early 1920s. A documentary film that could be said to be a contemporary notebook of the house that was given a new lease of life by Kogure-san was also apparently screened there. Kogure-san is now recruiting new immigrants to the village since he started work on the renovation of one more old farmhouse in 2015.

二・中立山の家

1 - A chunk of wood supports the main house beam that was damaged during the earthquake | 2 - Taking a break while rethatching the roof | 3 - The living room of the Kogure house | 4 - Kogure-san's goat

小白倉の家

十日町市最北に位置する「美しい景観の集落」として有名な小白倉。茅葺屋根の家がたくさん残るが今は全てトタンで覆われている。集落の伝統行事としてもみじ引き祭が9月初旬に行われる。1990年代半ばから、ロンドンの建築学校が毎年滞在し、制作しながら住民と交流している。戦後の産業では鯉が有名である。

民泊先の江口通博さんは、1970年代に20代で父親とともに鯉の養殖業をはじめるが、病気を機に養殖業をやめ、現在は精密機器の製造を自宅で行っている。またロンドンの建築学校のワークショップのコーディネートも行っている。

KOSHIRAKURA HOUSE

Koshirakura is famous for its "beautiful village landscape." One can see many thatched roof houses, but they are all covered with galvanized iron. The *Momijihiki* (pulling the maple tree) Festival takes place in September as one of the village's traditional events. Beginning in the mid-1990s, AA School (London) students stay in this village every year. They build temporary architecture or furniture while interacting with the residents. Carp are a well known post-war industry here.

小白倉の鯉の養殖池
THE CARP HATCHERIES OF KOSHIRAKURA

調査年月：2015年4月／調査対象：江口通博・田中一男（小白倉集落）／みんぱく研究員：深澤 孝史
Date: April 2015 / Researched: Michihiro Eguchi and Kazuo Tanaka, Koshirakura / Researcher: Takafumi Fukasawa

三・小白倉の家

渋海川の瀬替えを利用した日本最大級の鯉養殖池がつくられた理由と現在

江口通博さんが40年前、父親と一緒につくった大きな鯉の養殖池はもともとは渋海川の一部だった。越後妻有地域を流れる渋海川は激しく蛇行しており、江戸時代より「瀬替え」とよばれる、河川を掘削し付け替える土木工事が行われていた。小白倉の瀬替えは大きく蛇行した川を埋め立て、新田をつくるために江戸末期から明治にかけて行われたとのことだ。江口さん一家は、瀬替えで田んぼとして使われていた場所に土手をつくり、再び水を流し、池につくり変えたのだ。

雪深いこの地域では冬の間出稼ぎにいくのが主流だった。出稼ぎにいくと、長ければ半年も家を留守にすることもある。集落の人は、冬の間も定住しながら安定した収入をなんとか得られないかとさまざまな方法を模索した結果、近隣地域の山古志村で始まったとされる鯉の養殖業に目をつけはじめた。

鯉の養殖は集落でもっとも大きな産業となっていき、集落全体が連携して、まるでひとつの会社のようになっていっていたようだ。江口家のみなさんも日本各地に体当たり営業をかけてきたとのこと。

しかし、よい時期は長くは続かなかった。日本人の生活文化の変遷や、鯉ヘルペスなどの影響で売り上げは減少し、養殖業を続ける家は徐々に減っていった。

通博さんも当時体調不良だったこともあり、始めて10年ほどで養殖業はやめ、今では集落では1軒だ

1 - 棚田を利用した稚魚用の養殖池｜2 - 栄養たっぷりの養殖池に生息するおたまじゃくしはカエルに変態しない｜3 - 瀬替えでできた田んぼを利用した養殖池で泳ぐ錦鯉

三・小白倉の家

REASON FOR ONE OF JAPAN'S LARGEST CARP HATCHERIES TO BE BUILT USING THE RICE PADDIES CREATED BY ALTERING THE COURSE OF THE SHIBUMI RIVER, AND ITS PRESENT-DAY CONDITION

Michihiro Eguchi made carp hatcheries with his father at the age of 20, 40 years ago, by pouring water in the remains of the Shibumi River, which had be drained to produce rice paddies. Carp hatcheries were utilized as a source of local income for villagers of the snowy region, who hitherto had to leave the village for work during the winter.

Koshirakura flourished with the carp hatcheries. At the time it was almost as if the entire village itself had become a carp hatchery company. However, due to changes in culture and a bout of carp herpes virus, there was a decrease in hatchery operators. Michihiro-san also gave it up 10 years ago. At present, only a single house in Koshirakura continues in the industry via new routes through foreign buyers, like China.

Although carp give an elegant impression as symbol of Japanese culture, there is a cruel aspect behind the carp industry; only a single carp in a school of 10,000 young fish will be worthy of distribution. The remaining fish are disposed of.

けが続けており、中国など外国の販路を新たに開拓し続けている。

　日本文化を代表する優美な印象を与える錦鯉だが、一方で、その錦鯉の養殖の背景には過酷な一面もある。模様の出方で値段が決まる錦鯉は1万匹生まれた稚魚の中の1匹だけ売り物になるかどうかの世界とのことだ。売れないと判断された残りの鯉は処分されてしまう。

1 - The rice terrace used as a fish hatchery | 2 - Tadpoles living in the nutrient rich hatchery do not grow to be frogs | 3 - Carp swimming in the hatchery. The hatchery was originally rice fields which were created by altering the flow of the river.

29

ゲートボールの金メダル
THE GOLD MEDALS FOR GATEBALL

調査年月：2015年4月／調査対象：江口 通博（小白倉集落）／みんぱく研究員：深澤 孝史
Date: April 2015 / Researched: Michihiro Eguchi, Koshirakura / Researcher: Takafumi Fukasawa

三・小白倉の家

　江口家の居間の壁には膨大な数のメダルが物干し竿にかけられている。トロフィーや楯が飾られているお宅はたまに見かけるが、これほどのメダルが飾られている光景は始めてだ。
　いったいどんな優秀なスポーツ選手を輩出したのかと思い尋ねたところ、メダルの獲得者は通博さんの亡くなった父親で、老後に毎日のように行っていたゲートボールのメダルだという。
　集落の娯楽として愛されているゲートボール。越後妻有地域では雪の時期にも楽しめるようにと屋内ゲートボール施設も建てられている。

These are the many gateball medals belonging to Michihiro Eguchi's now deceased father. Gateball, a Japanese sport similar to croquet, was his hobby and it is said he played it nearly every day.

1

1 - ゲートボールの金メダル
1 - The gold medal for gateball

障子を切ってつくった猫の出入り口
THE CAT HATCH MADE BY CUTTING UP THE SHOJI PAPER DOOR

調査年月：2015年4月／調査対象：江口 通博（小白倉集落）／みんぱく研究員：深澤 孝史
Date: April 2015 / Researched: Michihiro Eguchi, Koshirakura / Researcher: Takafumi Fukasawa

三・小白倉の家

　江口通博さんは現在猫を4匹飼っている。いつも玄関の戸を半開きにして、猫たちが家と外を自由気ままに移動できるようにして共に生活している。家の中の障子も一番下の枠だけ短冊状に切れ込みが入っており、猫の出入り口になっている。
　江口家に民泊した際、夜中にこれまで耳にしたことのない雄叫びが家の中に鳴り響いた。なにごとかと驚いたが、どうやら家の中に侵入した野良猫と飼い猫との喧嘩の声だった。本気で怒りだすと飼い猫も信じられないほど凶暴な声を出すようだ。
　自由な雰囲気を感じ取ったのか野良猫まで中に入ってくる江口家。自由気ままに内と外を往来しているうちの猫は都会の飼い猫より幸せだと通博さんはいう。

Michihiro-san owns four cats. He always leaves the front door half open so that his cats can come and go as they please. However, because of this, stray cats often sneak in and get into fights with his cats. Michihiro-san says his cats are much happier than house cats in the city.

1

1 – 猫の出入り口
1 – The cat hatch

夕顔をめぐるかけあい
A DIALOGUE ABOUT BOTTLE GOURDS

調査年月：2015年8月／調査対象：江口 キヨノ（小白倉集落）／みんぱく研究員：田中保帆
Date: August 2015 / Researched: Kiyono Eguchi, Koshirakura / Researcher: Yasuho Tanaka

三・小白倉の家

　江口通博さんのお宅で夕顔を食べた。お味噌汁に入っていたり、魚やゼンマイと煮物にしたりする。食べるのももちろんだが、中身をくりぬいて乾かすと、ひょうたんのように使えるのだという。
　お酒が入ってご機嫌になった通博さんが乾かす手順を説明してくれるのを、奥さんのキヨノさんは渋い顔をして見ていた。
「この人、自分でやったことないのよ。」
と、キヨノさんも説明してくれたのだが、キヨノさんもやったことはないようで、何が本当なのかよくわからなかった。　この大きな夕顔は一体どうなるのだろう。

　At the Eguchi house, I ate a bottle gourd. It was in the miso soup with some fish and Japanese royal ferns. Bottle gourds are edible, but you can also clean the seeds out and dry them.
　In the midst of an explanation by a slightly tipsy Michihiro-san about how they are dried, his wife Kiyono-san made a funny face saying "He's never even dried one before." And so she began to explain the process. But, as it turns out, she has never done it herself either. The conversation became quite confusing. What is with these bottle gourds?

重石になったジンギスカン鍋と商品のしめ縄
THE REUSED JINGISUKAN SKILLET

調査年月：2015年4月／調査対象：江口 幸子（小白倉集落）／みんぱく研究員：深澤 孝史
Date: April 2015 / Researched: Sachiko Eguchi, Koshirakura / Researcher: Takafumi Fukasawa

40年ほど前の観光ブームの際、地域で流行ったらしい北海道名物のジンギスカン鍋。数年して使わなくなったが、畑に覆う黒ビニールなどの重石に使うのにちょうどよいということで、長年外で使われていた、というか雨ざらしになっていた。十日町市は土器が有名だが、錆びたジンギスカン鍋も独特な模様のおかげで旧時代の遺物に見えなくもない。

所有者の江口幸子さんも一時は鯉の養殖業に熱をいれていた一人だ。現在は主にしめ縄の内職を日々行っている。ミトラズという品種を稲がまだ青い夏の早い時期に収穫しそれを原料としている。

近代化以前はしめ縄つくりは農家の生活の一部だったが、現在は近隣の人々と内職で商品としてつくっているとのこと。しめ縄の需要は高いとのことだが、後継者不足で、今はできる範囲で行っているそうだ。

This is a Jingiskhan skillet, a lamb dish, left over from some 40 years ago when there was a boom in tourism to Hokkaido from this area. After losing its original use, it was discovered that it would work perfectly as a weight in the rice fields, and has therefore been utilized for this purpose. It looks like an ancient artifact.

三・小白倉の家

1

2

1 – 商品のしめ縄｜ **2** – 重石になったジンギスカン鍋
1 – The *shimewa* ｜ **2** – The jingisukan pan used as a weight

33

湯山の家

日本三大薬湯で有名な松之山の湯山集落。日本で三体しかないといわれるマリア観音のある松蔭寺や民俗資料館など地域の見どころもある。30年前までは特別天然記念物の大欅もそびえ立っていた。夏には集落の人々が44年前（1971年）に復活させた湯山神楽祭が催され、民泊調査もその日に合わせて行われた。民泊調査させていただいた草村邸は、松代、松之山で保育園の園長先生をされていた慶子さんと横浜から婿に入られた茂さんご夫婦の家で、別宅「ヤマト」にお邪魔した。

YUYAMA HOUSE

Yuyama Village is located in Matsunoyama, one of the three most famous medical hot springs in Japan. There are a number of attractions in the area, such as the Shoin Temple with the Maria *Kannon* Statue, and the folk museum. Until 30 years ago, there was a large Japanese elm tree, designated as a national natural monument, in this village. The Yuyama *Kagura* Festival, which the people of the village revived 44 years ago, is performed in the summer.

梁の上の油絵（父、夫、娘）
THE OIL PAINTINGS ABOVE THE BEAM (FATHER, HUSBAND AND DAUGHTER)

調査年月：2015年8月／調査対象：草村 慶子（湯山集落）／みんぱく研究員：深澤 孝史
Date: August 2015 / Researched: Keiko Soumura, Yuyama / Researcher: Takafumi Fukasawa

四・湯山の家

この地で暮らす意味の詰まった、元保育園の園長先生の描きつづける油絵

　草村慶子さんのお宅には、梁の上に何枚もの油絵が掛けられている。図版の真ん中の大きな絵は慶子さんが湯山神楽を演じている夫を描いたものである。

　夫の茂さんは、横浜で塗装業を営んでいたが、肌に合わず、当時横浜の短大で保育を学んでいた慶子さんと出会い、転地療養も兼ね松之山へ婿入りしたのだ。当時の都会の空気が相当悪かったのか、茂さんの親兄弟はみな50代で亡くなってしまったが、松之山に越してきた彼だけが今も元気に暮らしている。

　右の絵は慶子さんの娘の成長を追い続けて描いているシリーズの一枚で、彼女のライフワークにもなっているものだ。慶子さんは中学2年の時、美術教師に油絵を勧められてからこれまで描き続けており、保育園の仕事にもとても役立ったとおっしゃっている。

　左の絵は、慶子さんの両親を描いたものだ。慶子さんの父は出稼ぎで植木職人をしていた。しかし、ある時木から落ちてしまい、それ以来体調を崩してしまった。家でもうつむきがちになってしまった様子を見て慶子さんが、父に上を見上げてもらい、もっと元気になってほしいと願ったことから、油絵は梁の上にかけられている。

1 - 娘の成長を描いたシリーズ｜**2** - 夫の茂さんが演じる湯山神楽｜**3** - 慶子さんのお宅に飾られている様子

OIL PAINTINGS BY A FORMER NURSERY SCHOOL PRINCIPLE, FILLED WITH WHAT IT MEANS TO LIVE IN THIS AREA.

There are many oil paintings displayed above the beam at Keiko Soumura's house. The picture in the middle of the three pictures of the photo (P.36) is of Keiko-san's husband performing the Yuyama *Kagura*, a Shinto song and dance. He had worked in the paint industry in Yokohama, but met Keiko-san who studied nursery at college, and left Yokohama for Matsunoyama, her homeland, to help cure the adverse skin reactions. He got married, taking on Keiko-san's family name. He is the only one left of his family, all of whom passed away in their fifties, perhaps due to the harsh city air. However, he is still living healthily in the countryside.

The painting on the right is Keiko-san's greatest work, her daughter. Keiko-san was first recommended to try oil painting by her art teacher when she was in the eighth grade. She has been painting ever since, and says it was very useful when she worked at the nursery school.

The painting on the left is of Keiko-san's parents. Her father left the village to work as a gardner, but became bedridden after falling from a tree. She put the oil paintings on the ceiling beam to encourage her father to "keep his head up" during his tough times.

四・湯山の家

1

2

3

1 - Keiko-san's daughter's growth captured in paintings | 2 - Shigeru-san performing the Yuyama *Kagura* | 3 - Paintings decorating Keiko-san's home

37

お盆になったキャンバス
THE CANVAS USED AS A TRAY

調査年月：2015年8月／調査対象：草村 慶子（湯山集落）／みんぱく研究員：深澤 孝史
Date: August 2015 / Researched: Keiko Soumura, Yuyama / Researcher: Takafumi Fukasawa

四・湯山の家

　草村慶子さんは、家の向かいに別宅を購入し「ヤマト」と名付け、そこに毎週子どもたちを集めて音楽あそびの時間を設けている。今回の民泊はそちらにお邪魔してお泊まりをすることになった。

　慶子さんが朝ごはんを本宅でつくって運ぶとき、お盆が足りなくなって使ったのが未使用の油絵用10号キャンバスだった。

　油絵が生活に結びついているからなのか、はたまた慶子さんの人柄がでているのか、初めて見る光景がそこにはあった。

Keiko Soumura purchased the house opposite hers to have music sessions every week with the local kids. I stayed there for my homestay research.

In the morning, Keiko-san made breakfast and carried it over to her second house. However, since there weren't enough trays to go around, she substituted with an unused number 10 painting canvas.

Perhaps this is an aspect of the oil painter's lifestyle, or perhaps this is just Keiko-san's personality; but it was the first time for me to see such a sight.

あんしんのトイレットペーパー
THE TOILET PAPER MADE BY ANSHIN

調査年月：2015年8月／調査対象：草村 慶子（湯山集落）／みんぱく研究員：白川 みどり
Date: August 2015 / Researched: Keiko Soumura, Yuyama / Researcher: Midori Shirakawa

四・湯山の家

　トイレのドアを開けると、窓辺に見なれない青い包み紙のトイレットペーパーがふたつ並んでいた。「ん？ 夢工場あんしん？　チャンスをください……」
　十日町市にある障害者福祉作業所「ワークセンターあんしん」の雑古紙再生のトイレットペーパーである。
　このペーパーと草村家の出合いは、1997年頃、慶子さんが勤めていた保育所に施設の方がペーパーを紹介に来た時である。保育所で使用し、自宅でも長年にわたって使われてきた。
　日々の暮らしの中で使われている、これこそ慶子さん曰く「香料もなく、自然で使い心地が良く一番好き！」という草村家に愛されているトイレットペーパーなのである。

　When I opened the bathroom door, I found two rolls of toilet paper on the window sill wrapped in an unfamiliar blue paper. On the paper was written "*Yume Kojo* (Dream Factory) *Anshin* (Safety) Give Us a Chance." It was toilet paper made from recycled paper by Yume Kojo Anshin, a local factory that works with handicapped people.
　The Soumura family first came across this toilet paper back in 1997, when Keiko-san was introduced to it by someone from the preschool where she used to work. Since then, they have used it at the preschool as well as in their own home.
　Keiko-san often says of the toilet paper "It doesn't have any artificial scents and feels very natural. We like it best of all!" This beloved toilet paper is another part of life in the Soumura house.

集落の親睦のため44年前に復活した湯山神楽
THE YUYAMA *KAGURA*, REVIVED 44 YEARS AGO TO PROMOTE SOCIALIZATION AMONGST THE LOCAL PEOPLE

調査年月：2015年8月／調査対象：滝沢正彦（湯山集落）／みんぱく研究員：深澤 孝史
Date: August 2015 / Researched: Masahiko Takizawa, Yuyama / Researcher: Takafumi Fukasawa

四・湯山の家

　長年続いてきた湯山の神楽は、戦後に一度途切れたが、1971年に集落の10代20代の若者が集まって、集落の親睦を深めるために復活させ、現在に至る。

　途切れる前の神楽を知っていた二人の老人に昔の神楽の型を聞き取り、再興させたとのこと。毎年8月の最終土曜日に催される。

　30年以上前、地元の美術の先生が獅子頭を軽くしようとFRPで制作したが、いざ完成すると、ずっと使われていた桐の獅子頭の方が軽いことがわかり、FRPの獅子頭は結局本番では使われず、練習用に用いられている。

After the war, people no longer performed the Yuyama *Kagura*, but in 1971 it was revived by the younger members of the village to help strengthen the bonds of friendship with other villagers.

The *kagura* was revived by asking two elderly locals who knew of the kagura before the war. The Yuyama *Kagura* is performed on the last Saturday of August. The *shishi* lion mask was made 30 years ago when a local art teacher theorized that the mask would be much lighter if it was made using a fiber reinforced polymer. However, after actually constructing the new mask, it was discovered that the original mask made from *kiri* wood (Paulownia tomentosa) was actually lighter. In the end, the polymer mask was never used in the performance, and was reserved for practice only.

参加型寸劇の柿の実
PERSIMMONS IN THE HANDS OF THE AUDIENCE, AND A SHORT PLAY

調査年月：2015年8月／調査対象：湯山集落／みんぱく研究員：深澤 孝史
Date: August 2015 / Researched: Yuyama Village / Researcher: Takafumi Fukasawa

四・湯山の家

　44回目の湯山神楽祭ではメインの獅子と天狗の大々神楽の後に屁こき嫁の寸劇が行われた。

　台本は毎年小口公夫さんが書かれている。前々回に反原発的な内容の劇をつくって批判された経験を踏まえ、見方を変えると悪いものもよいものにみえるかもしれないという示唆的な内容となった。

　湯山神楽祭は20もの演目があり、各演目が終わるたびにティッシュにくるんだおひねりを舞台に投げる。そのしくみを利用し、屁で柿の実を落とすシーンでは、おひねりとともに玉入れの玉でつくった柿の実を投げてもらう参加型アトラクションを取り入れていた。

　For the 44th Yuyama *Kagura* performance, the main *Shishi* (lion) and *Tengu Daidai Kagura* performances were followed by the short play *He Koki Yome* (The Farting Bride). Every year the scripts are prepared by Kimio Koguchi.

　There are twenty acts, and after every act people throw coins wrapped in tissue (called *ohineri*) onto the stage. Playing on this custom, there is a bit of audience participation when, during the scene where some persimmons are knocked over by a fart, along with the *ohineri*, the audience also throw small persimmons made out of hacky sacks.

小荒戸の家

小荒戸はまつだい駅から歩いて10分ほどの渋海川沿いの集落。調査した家は先代まで豆腐屋を営んでおり、その名残が随所に残っている。奥さんは家業の豆腐屋をたたんだ後は、押し花作家として活動をしている。

KOARATO HOUSE

Koarato Village is located along the Shibumi River, a 10 minutes' walk from Matsudai Station. The house being surveyed here used to make and sell *tofu* in previous generations, evidence of which is ample throughout the house. Since they closed the *tofu* store, the wife has been working as a pressed flower artist.

油揚げと押し花
PRESSED FLOWER CRAFT WITH DEEP FRIED *TOFU*

調査年月：2015年6月／調査対象：五十嵐 江美子（小荒戸集落）／みんぱく研究員：深澤 孝史
Date: June 2015 / Researched: Emiko Igarashi, Koarato / Researcher: Takafumi Fukasawa

五・小荒戸の家

家業の豆腐屋で続けてきた油揚げと
つながる押し花

　小荒戸集落の入り口に位置する五十嵐江美子さんの家は、先代まで豆腐屋を営んでいた。40年前に江美子さんの父が突然亡くなり豆腐屋をたたむことになった。家の中に建てられていた大豆を挽くための大きな水車も使われなくなると、ほどなく朽ちてしまった。当時お悔やみごとなどがあると供養品として大量の油揚げをつくっていたそうだ。油揚げは、重石で段階的に徐々に押しつぶした豆腐を揚げてつくっていた。

　閉店してから20年たったある日、江美子さんは夫の単身赴任先でたまたま押し花教室の案内がテレビで放送されているのを見て、教室に通い始め、押し花の作品をつくるようになった。押し花は江美子さんにとってものすごく相性のよい制作活動だった。生まれも育ちも豊かな自然に囲まれた小荒戸では、目につくもののほとんどが作品の材料となる。季節ごとに集めた素材は乾燥パックにいれて必要な時にいつでも使えるように保管されている。この蓄積が江美子さんのもっとも重要な押し花の材料となっているのだと感じた。

　重石で平たくするものが、豆腐から花に代わった江美子さんは、今では作品が市の美術展で入選するほどの腕前になった。

1 - 豆腐屋時代に使われていた木箱｜**2** - 豆腐の型箱｜**3** - 豆腐屋の看板・おからを餌にして豚も飼っていた｜**4** - 押し花の素材を収納しておく乾燥シート

PRESSED FLOWERS AND THEIR CONNECTION TO THE FRIED *TOFU* OF THE FAMILY-RUN *TOFU* STORE

Just inside Koarato Village, which is a stone's throw away from Matsudai Station, can be found Emiko Igarashi's house, which had, until the most recent generation, operated a *tofu* shop. The shop was closed up 40 years ago, when Emiko-san's father suddenly passed away. The water mill constructed within the house to grind the *daizu* beans has begun to rot away from disuse. Emiko-san always makes fried *tofu* for the various ancestral offerings given in Japan. Fried *tofu* is made by frying *tofu* that has been slowly and gradually pressed using a weight.

20 years after the *tofu* shop closed, Emiko-san happened to see an advertisement on TV for a flower pressing class while visiting her husband, who had been transferred out of the village. After that, she began making her own pressed flower artworks. She went from pressing *daizu* to pressing flowers. Now she has polished her skills to a level where she has even won a prize from the city art museum.

1 - The wooden box used for making *tofu* | **2** - The *tofu* mold | **3** - The *tofu* makers sign; The pig was raised on soy pulp | **4** - The drying sheets used to store pressed flowers

小荒戸の盆踊りの全員あたるくじ引き
KOARATO VILLAGE'S *BON* DANCE AND THE LOTTERY THAT EVERYONE WINS

調査年月：2015年8月／調査対象：小荒戸集落／みんぱく研究員：中田一会・黒部順子
Date: August 2015 / Researched: Koarato Village / Researchers: Kazue Nakata and Junko Kurobe

五・小荒戸の家

　小荒戸集落では20数戸の住民のための小さな盆踊り大会が毎夏開催される。そのクライマックスを飾るのが、ちょっと変わったくじ引きだ。

　盆踊りをしながら参加者全員がくじを引き、曲が止まったら賞品タイムのはじまり。番号が読み上げられ、某高級デパートを思わせるバラ柄の包み（でも髙島屋のそれではない）が渡される。中身は全て100円程度の日用品で、大当たりもハズレもなし。賞品は余るほどあるから、全員もれなくあたるくじ引きなのだ。

　1曲ループ再生の盆踊り、1種類だけの焼き鳥、手持ちの花火、そして全員あたる小さなくじ引き。人の気持ちを楽しくさせるお祭りのミニマムな形が、小荒戸の盆踊りとくじ引きには宿っていた。

　Every summer, the twenty or so houses in Koarato Village have a small *bon* dance festival. The gem of the festival is the lottery that happens at the end.

　If your number is called, you get a small present wrapped in what looks like paper from some famous shopping mall (but not the famous one). Inside the wrapping is an everyday product you could purchase for a hundred yen. There is no grand prize, but everyone is a winner. They have enough prizes to give to everyone, with some left over. The people dance to a single song played on loop, enjoy a single type of *yakitori*, let off small hand-held fireworks, and hold a lottery that nobody loses. Hidden in Koarato's *bon odori* and lottery are the bare essentials needed to have an enjoyable and simple celebration.

五十嵐茂義さんのアートマネジメント
ART MANAGEMENT BY SHIGEYOSHI IGARASHI

調査年月：2015年8月／調査対象：五十嵐茂義（小荒戸集落）／みんぱく研究員：中田一会・黒部順子
Date: August 2015 / Researched: Shigeyoshi Igarashi, Koarato / Researchers: Kazue Nakata and Junko Kurobe

　小荒戸集落では、大地の芸術祭ごとにアーティストが訪れ、作品制作やワークショップが行われる。受け入れる集落の負担は決して軽くなく、コーディネーター的存在が重要だ。

　小荒戸集落では元公務員の五十嵐茂義さん（70歳）がボランティアでその役を担っている。住民に参加を呼びかけ、自身も積極的に制作に関わり、設置場所でもめた際には管轄行政と掛け合い、おもてなし用に集落のユニフォームを作り、作家とは作品メンテナンスの相談、次回作のイメージの聞き取りなども行い、住民とのつき合い方もそれとなく伝えたりする。現役時代は県庁や関連団体で医療福祉畑をずっと歩んできたそうだ。五十嵐さんのケアの精神がアートの現場でも発揮されているのかもしれない。

In Koarato Village, for every Echigo-Tsumari Art Triennale, artists are invited to create artworks and hold workshops. This is by no means a light task for the village, and a strong presence to coordinate the different events is very important.

In Koarato, former civil servant, Shigeyoshi Igarashi (70 years old) has volunteered to fill this role. He always listened to the artists' ideas for their future projects and was a great coordinator between the villagers and the artists. For a long time he used to be a medical welfare worker for the prefectural government and related organizations. His knack for welfare is perhaps what is making him such a good leader on the art front.

五・小荒戸の家

「五十嵐流アートマネジメント名語録」（中田一会 編）

アートとの付き合い方について、五十嵐茂義さんのお話から学んだことを、語録としてみんぱく研究員が書き起した。

悪者になる勇気
アート制作の現場はいつだって板挟み。
芸術祭と住民、作家と設置場所の持ち主……。間に入りながら、
「自分が悪者になってすむならば」
と、時に叱られ役も引き受けるべし。

収穫祭に酒瓶2本でいいから
小荒戸集落は、芸術祭初期から協力的だ。しかし地域と良い関係を続けるにはコツもいる。
地域付き合いのヒントとして差し入れ等をアーティストに助言することも大事な役割。

なにやってもOKの状況をつくる
やりたいことと、やれることの間には大きな溝がある。諦めることは簡単だが、
「かっこいい中に収まっているものはだめ」
と感じたなら、作家の自由を全力で確保するべし。

素早く先回り
アーティストとは自由につくり続ける人々。
本来は設置NGな場所に作品が置かれたとしたら、クレームが入る前に管轄行政にさっと交渉へ。
柔軟な対応と先回り力が求められる。

住民との付き合いは平等に
芸術祭の里とはいえ、住民とアーティストの関係は常に繊細だ。
一部の住民とアーティストが仲良くなるのではなく、全員が対話できるように心配るのはとても必要なこと。

あるべき姿はアーティストが知っている
四季折々まったく違う姿を見せる越後妻有。
作品も常に変化にさらされ、その度にメンテナンスが必要になる。
雑草抜きひとつでも作品のあるべき姿をアーティストと相談するべし。

作品の記憶を慈しむ
集落には、過去作品の軌跡があちこちに。作品の素材だったり、解体された展示の一部だったり。
自分たちが一緒に作ったという自負があるからこそ、住民がいつまでも大事に残す。

五・小荒戸の家

A COLLECTION OF SAYINGS ABOUT ART MANAGEMENT BY MR. IGARASHI edited by Kazue Nakata

A researcher transcribed what she learned about art management by quoting Mr. Shigeyoshi Igarashi directly.

THE GUTS TO BE THE BAD GUY
"In art production, you are always caught in the middle; be it between the festival organizer and the local people, or the artists and the owner of the site, you are always in the middle. You should always be ready to be the bad guy and take the blame if that's what it takes to get things done."

TWO BOTTLES OF SAKE IS ALL THAT IS NEEDED
"Koarato Village has been cooperative in regards to the festival from the very beginning. However, there is a trick to maintaining good relationships with the community. I always advise artists that, as a way to grease the wheels with the locals, it is a good idea to come with a small gift."

CREATING A SPACE WHERE ANYTHING IS O.K.
"There is a massive gap between what we want to do and what we can do. It is easy to give up. If you feel that you want art that isn't just cool to look at, but has meaning, you must protect the artist's freedom with all your power."

BE PROACTIVE!
"Artists are people who need freedom to create. If you are putting up art in a place that originally didn't allow it, you should be proactive with talking to the administration. Start negotiations before anything negative happens, or anyone has the chance to complain. Being flexible and proactive are very much sought-after characteristics."

DON'T PLAY FAVORITES WHEN INTERACTING WITH THE LOCAL PEOPLE
"Even in the area called the 'art field,' the relationship between the artists and the local people is very delicate. It is important to make the effort so that not just a few of the local people, but everyone has some dialogue with the artist."

ARTISTS KNOW THE IDEAL SITUATION
"The four seasons in Echigo-Tsumari are all completely different. The art as well will continually fall victim to this change, so proper maintenance is vital. It is important to bang out the kinks through discussions with the artist, who will know what is best for each piece."

LOVE THE MEMORY OF EACH PIECE
"In the village, you can find the remains of different art pieces here and there; chunks of different pieces or parts remaining after pieces were taken down. There is a feeling of pride they have with the objects they helped construct, and so they always hold great importance for these remains."

松代の家

十日町市街地から名ケ山を越えたところにある松代。ほくほく線や名ケ山のトンネルなどが開通し交通の利便性がどんどん向上している。調査したお宅はまつだい駅から徒歩10分ほどに位置する柳家。能弘さんは隣の松之山出身で、定年まで旧松之山町の職員として働いてきた方だ。妻のハルエさんは松代の方で、彼女の父は郵便局員をしていた。まだ電車もトンネルも開通していない頃は雪の峠を越えて郵便配達をしていたそうだ。定年後も二人は、農業をしながら松代のさまざまな活動の下支えをして暮らしている。

MATSUDAI HOUSE

Matsudai is located beyond Myoukayama from Tokamachi. Since the Hokuhoku Line and Myoukayama tunnel opened, the convenience of local transport has steadily improved. The Yanagi house is located a 10 minute walk from Matsudai Station. Yoshihiro Yanagi was born in neighboring Matsunoyama and worked as a town official until retirement, and his wife was born in Matsudai. Her late father was a postal worker who used to walk all the way over the mountain in the winter. The couple has been supporting various activities while farming.

冬季保存用の野菜の瓶詰め
JARS OF PRESERVED VEGETABLES FOR WINTER

調査年月：2015年8月／調査対象：柳 能弘（松代集落）／みんぱく研究員：佐野 翔
Date: August 2015 / Researched: Yoshihiro Yanagi, Matsudai / Researcher: Sho Sano

六・松代の家

　十日町市周辺では、冬の間、3〜5メートルほどの積雪があり、住民は雪とともに暮らすための工夫を惜しまなかった。各家庭でもさまざまな方法があり、松代に住む柳家の場合、春夏秋に収穫した根曲竹の筍やモグラキノコを煮沸しビンに詰めて保存する。

　またイチゴジャムなども作り、これらは1年以上の備蓄に耐え、蓋に書かれたマジックペンの日付がそれを物語る。時と共に白い灰汁が沈殿したり、変色するが、密閉してあれば問題なく食せる。5月頃に採れたゼンマイも乾物にし、虫除けの山椒と共にパッキングする。水に浸け1〜2日戻して食す。米もあるので災害時も1週間以上は暮らせる。

　「ゼンマイは水で戻さず食べて文句をいう人がいるから、わかる人にあげてるの」

　ハルエさんのさりげない言葉に自分たちで山の恵みを採集、保存する工夫と知恵の重みを感じた。

　In the winter, Tokamachi can get 3-5 meters of snow, so the local people have had to come up with different tricks to help survive the winter. Each house has its own system. The Yanagi house in Matsudai cans *Nemagari-bamboo* and *Mogura-kinoko* which they harvest throughout the rest of the year.

　The Yanagis have also made jams of strawberry and other fruits and vegetables, which can be preserved for over a year. Once, when Harue-san casually said, "Sometimes, people don't realize they need to let the fern soak before they eat it, and they complain. So we give it to people who know how to prepare it." This made me realize the stockpile of wisdom this couple has regarding the harvesting and preserving of mountain foods.

民泊体験をした子どもたちからの贈り物
PRESENTS FROM THE HOMESTAY CHILDREN

調査年月：2015年8月／調査対象：柳 能弘（松代集落）／みんぱく研究員：島田一宏
Date: August 2015 / Researched: Yoshihiro Yanagi, Matsudai / Researcher: Kazuhiro Shimada

　1996年に企画自体の種が植えられ、2000年よりスタートした「大地の芸術祭 越後妻有アートトリエンナーレ」。2015年で6回目の開催になる。

　企画の種植え時から今もなお携わり、参画し続けている柳能弘さん、ハルエさんご夫婦のお宅に民泊した。

　自分たちの土地を愛し、自分たちが先人の方々から引き継いだバトンを次の世代へしっかり繋いでいくために日々奔走されている。大地の芸術祭では作品の受付などを勤める一方で、自宅では都内の小中学生を民泊で受け入れ、共に生活を送る中で「土地のこと」や「これからの生き方」「豊かさ」について伝え、問いかけている。

　家には民泊を通じて繋がった学生たちからの贈り物が並ぶ。柳さんの継続的な活動は、民泊体験をしていった子どもたちに確実に通じているように感じた。

　The seed was first planted in 1996, and in the year 2000 "Echigo-Tsumari Art Triennale" was born. From the project's fledgling stages to the present day, the Yanagi family, Yoshihiro and Harue, have been heavily involved.

　The couple love their hometown and spend their days scrambling around to make sure they can properly pass on to the next generation the baton that has been passed on to them from their ancestors. They also have kids from the city come and stay with them for a day or two to experience country life and discuss the meanings of "land," "future," and "wealth."

　They have a collection of all the gifts they have received from the children who have stayed at their home. I really feel the Yanagis' continuing efforts have had an important impact on these kids.

六・松代の家

昭和町の家

十日町市の中心市街地。駅から歩いて5分ほどの場所に昭和町はある。昭和30〜40年代がもっとも織物産業でにぎわっていた。民泊する予定だった関口家は大工を営んでおり、奥さんが家の向かいにひきこもり支援スペースを開いている。奥さんの美智江さんは川西の星名新田という現在は廃村になった集落から嫁いできた。家の都合で美智江さんの家には民泊できなくなり、その隣の家の樋口守雄さんのお宅に泊めてもらうことになる。樋口さんは相撲界に織物を卸す会社を経営していた方だ。

SHOWA-CHO HOUSE

Showa-cho is the central district of Tokamachi City, a five-minute walk from the station. It was once a busy textile-manufacturing district. This house is run by a carpenter and his wife, who opened the space to help with *hikikomori* (social withdrawal) across the street. We stayed at the house next to it, whose owner, Morio Higuchi ran a textile company that wholesaled to the sumo community.

樋口守雄相撲ミュージアム
MORIO HIGUCHI'S SUMO MUSEUM

調査年月：2015年8月／調査対象：樋口 守雄（昭和町）／みんぱく研究員：石橋 鼓太郎
Date: August 2015 / Researched: Morio Higuchi, Showa-cho / Researcher: Kotaro Ishibashi

七・昭和町の家

自身の生い立ちと街の産業との重なりからうまれた生業

　北海道出身の樋口守雄さんは、十日町市の名産である織物を東京の相撲界に卸すお仕事を長年なさっていた方だ。守雄さんの父が津南出身で、仕事で東京に出てきた守雄さんはその縁もあり、織物が最盛期だった十日町市に引っ越してきた。昭和30年代に仲卸の会社で働き、40年代に相撲界に着物を販売する会社を自ら立ち上げた。

　このたび宿泊させていただいたお宅にも、あらゆる相撲関連グッズがあった。ご自身が相撲の「十日町場所」を主催した際の記念の番付、小錦関との記念写真、当時卸していた織物、そして、むかし東京の相撲部屋で何度も作ったという、絶品のちゃんこ鍋。

　ご自身も幼少期に身体が弱く、「たくさんちゃんこを食べて運動したら身体も丈夫になるから」と相撲部に入部していた。それが巡り巡って、商売の取引先として相撲界とどっぷり関わることになったらしい。そして今、私たちに絶品のちゃんこが振る舞われている。

　十日町市の織物産業と相撲界の関係、そして個人の過去と現在が、さまざまな形で体感できる守雄さんのお宅は、さながら「ミュージアム」のようであった。

1 - 稀勢の里が横綱になったら贈ろうと思ってつくった反物｜2 - 守雄さんが勧進元となった十日町場所の板番付｜3 - 現役時代の小錦とのツーショット

FINDING YOUR CAREER WHERE YOUR HISTORY AND YOUR TOWN'S INDUSTRY OVERLAP

For a long time, Morio Higuchi wholesaled the special local Tokamachi textile products to sumo wrestlers in Tokyo. When I did my homestay at his house, I found several sumo memorabilia here and there. Among these things was a sumo list from when Higuchi-san ran the "Tokamachi Sumo Tournament," as well as a picture of him with the famous sumo wrestler Konishiki and a sample of the textiles he sold at the time. There is also his famous *chanko nabe* stew, which he made many times at sumo stables in Tokyo. Higuchi-san got into sumo because, as a child, he was very weak. But he was able to strengthen his body through exercise and *chanko nabe* stew. As time went on, he ended up becoming heavily involved in the sumo world via his job in wholesales. In the present, he is constantly serving up his famous *chanko nabe*.

Higuchi-san is a multi-faceted man, with his work in Tokamachi textiles and with the sumo world, as well as his unique past and present. In this sense, his house itself is a bit of a museum.

1 - The fabric Morio planned to give Kisenosato if he ever became a *yokozuna* | **2** - The Sumo ranking list for Morio's "Tokamachi Sumo Tournament" | **3** - Morio with Konishiki during his wrestling days

廃村になった星名新田の目に見えない風景
THE INVISIBLE SCENERY OF HOSHINA SHINDEN, AN ABANDONED VILLAGE

調査年月：2015年8月／調査対象：関口 美智江（昭和町）／みんぱく研究員：太田祐輝
Date: August 2015 / Researched: Michie Sekiguchi, Showa-cho / Researcher: Yuki Ota

いまは廃村となり、一部の耕作者のみでわずかな棚田を守っている集落・星名新田。関口美智江さんが生まれ育った故郷である。

今はもう全ての家は取り壊され、その面影はないが、美智江さんは正確に各家庭の井戸の場所を覚えており、ここは台所で、こっちは風呂場、と私たちには見えない風景を案内してくれる。美智江さんの記憶の中には、いまだ往時の村の様子が描かれているのだろう。私たちが美智江さんの記憶の全てをたどることは到底できないが、断片的なそれらに触れることで、ここに確かに人々の暮らしがあったことを感じ取ることができた。そして池のなかでぷかぷかと安らぐカエル、井戸を守るスズメバチは私たちに強烈な印象を与えた。

七・昭和町の家

Hoshina Shinden is a ghost village with terraced rice fields that are maintained by only a handful of farmers. This is the hometown of my host mother, Michie-san.

At present, all the houses have been taken down, and nothing remains to even hint that they once existed. However, Michie-san remembers where each house's well was; where the kitchen and the bathroom once stood. She gave us a grand tour of a house that was no longer there. Even now, in Michie-san's memory, there exists the village from days long gone. It would be impossible for us to retrace all of her memories, but we can really get a sense of the lives of the former village as we interact with these fragments of her past. The black-spotted frogs floating in the ponds, and the wasps guarding the well also left quite an impression on us.

1 – マブ（トンネルで川筋を変えたもの）｜2 – 実家跡地のため池に住むトノサマガエル
1 - Mabu (A tunnel dug to change the course of a river) | 2 - Frog living in a pond near where the house once stood

冷蔵できない冷蔵庫
THE REFRIGERATOR THAT DOESN'T REFRIGERATE

調査年月：2015年8月／調査対象：関口 美智江（昭和町）／みんぱく研究員：長津結一郎
Date: August 2015 / Researched: Michie Sekiguchi, Showa-cho / Researcher: Yuichiro Nagatsu

十日町市街地の昭和町にある、引きこもりの人を支援するスペース「ねころんだ」。昭和町に住む関口美智江さんが、息子さんが引きこもりになったことをきっかけに立ち上げた場所だ。

部屋の中央には冷蔵庫が置かれている。家庭の冷蔵庫のようにいろいろな張り紙がしてあるが、コンセントが抜かれており冷蔵庫としての機能は持っていない。中を開けると日用品や事務用品などが整然と収納されている。よく見ると、助成金を貰った記念品の時計がしまってあった。利用者から「この部屋に時を刻むものはふたつもいらない」といわれしまったのだという。ほかにもチョコレートやペットボトルも混じっている。いかにも冷蔵庫らしいそのフォルムから食べ物や飲み物も入れてしまうようだが、実際にはただの棚なのである。

"Nekoronda" is a place in Showa-cho designed to help *hikikomori*, people who have withdrawn from social life. Michie-san established it when her son became *hikikomori*.

In the middle of Nekoronda, you can find a refrigerator. Just like your refrigerator at home, it is decorated with lots of different pieces of paper. However, it is never plugged in, and is, in fact, completely broken. If you open the door, you will find a lot of everyday items and office supplies neatly lined up inside. The fridge contained many different things, and every now and then you could find some chocolate or some drinks thrown into the mix. While it was most certainly a refrigerator, and every now and then you could find typical fridge foods and drinks in it, in actuality, it was little more than a shelf.

七・昭和町の家

1 - 工事用の黒板を利用した「ねころんだ」の看板 | 2 - お酒好きの利用者さんが率先してつくった禁酒・禁煙ポスター
1 - The Nekoronda signboard was originally a construction site blackboard | 2 - The no-smoking, no-drinking posters initiated by the sake lovers

姿の家

姿は十日町市の中心市街地から車で10分ほどの距離にある集落。門脇洋子さんは地域おこし協力隊として2010年より十日町に住んでいる。大学時代より40年間、十日町の鉢集落に民俗資料調査でかかわっており、現在も地域の民俗資料や、ミニコミ誌などの保存活動を継続中である。「門脇さんの民俗資料シリーズ」は、門脇さんの調査資料をお借りした。

SUGATA HOUSE

Sugata Village is located a 10 minute car drive from central Tokamachi City. The resident of this house has been a member of the Local Activation Team in Tokamachi since 2010. Since graduating college 40 years ago, she has been involved in folk research in Hachi Village. She is continuing her preservation activities and archiving zines of the region's folklore.

門脇さんの民俗資料1　鉢の石仏
KADOWAKI-SAN'S DOCUMENT 1: THE STONE BUDDHAS OF HACHI

調査年月：2015年6月／調査対象：門脇 洋子（姿集落）／みんぱく研究員：深澤 孝史
Date: June 2015 / Researched: Yoko Kadowaki, Sugata / Researcher: Takafumi Fukasawa

八・姿の家

　2010年に十日町市に地域おこし協力隊の制度[※]で移住した門脇洋子さん。40年前から大学の調査で鉢を訪れており、住み始めたのは最近だが、関わり自体はとても長い。調査目的は鉢集落の石仏を文化財に指定することだった。このときのさまざまな親交が今も続いており、洋子さんの現在の十日町における活動に結びついている。

※総務省が平成21年度から取り組んでいる事業。人口減少や高齢化などが著しく進む地方へ、都市部の意欲ある人材が移住（最長3年）し、地域力の維持・強化を目的とした支援活動を行う。

　In 2010 Yoko Kadowaki moved to Tokamachi after continually visiting the area for 40 years while gathering documentation to have Hachi's stone Buddha statues designated as an official cultural asset. During this time, she made many strong connections with fellow researchers that remain as deep friendships to this day; even finding themselves tied to her present projects.

門脇さんの民俗資料2　尾身ミノさんについて
KADOWAKI SAN'S DOCUMENT 2 : REGARDING MINO OMI

調査年月：2015年6月／調査対象：門脇 洋子（姿集落）／みんぱく研究員：深澤 孝史
Date: June 2015 / Researched: Yoko Kadowaki, Sugata / Researcher: Takafumi Fukasawa

　鉢の石仏の調査の際に門脇洋子さんがお世話になった旧真田小学校の給食のおばちゃん、尾身ミノさんについて、門脇さんのグループがまとめた資料群がある。ミノさんの夫は木挽職人だったが、若くして亡くなられた。十日町市博物館発行の冊子には、ミノさん自身が夫についてまとめた文章が掲載されている。

　門脇さんたちのグループが、現在は空き家となったミノさんの家を民俗資料館「石仏・語らいの家」として期間限定でオープンさせた活動の資料もある。門脇さんの現在住んでいる家の名前も「木挽亭」と名付けられ、ミノさんの夫が使っていた木挽鋸なども所蔵している。

　Kadowaki-san's group has collected and organized documents regarding Mino Omi, the cafeteria worker at the former Sanada Elementary School, which was great help during her research into the stone Buddha statues of Hachi.

　Mino-san's husband was a logger, but died at a very young age. Descriptions of her husband in her own words can be found in the bulletin of Tokamachi City Museum. In 2012, for a limited time, Kadowaki-san opened up Omi-san's now empty house as a folk museum called "Ishibotoke: Katarai No Ie" meaning "The Stone Buddhas: Conversation House".

八・姿の家

門脇さんの民俗資料3　じょんのび通信
KADOWAKI SAN'S DOCUMENT 3: THE *JONNOBI* NEWSLETTER

調査年月：2015年6月／調査対象：門脇 洋子（姿集落）／みんぱく研究員：深澤 孝史
Date: June 2015 / Researched: Yoko Kadowaki, Sugata, / Researcher: Takafumi Fukasawa

八・姿の家

　門脇洋子さんは2010年、神奈川県の逗子から40年間通い続けていた十日町市に、ついに移住した。きっかけは年齢制限のなかった十日町市の地域おこし協力隊の制度だ。鉢の尾身ミノさんの空き家に引っ越そうとしたが叶わず、姿の民家に引っ越した。

　「じょんのび通信」は地域おこし協力隊の活動広報紙である。また、NPO「ひとサポ」で地域ネットワークをつくる仕事をしながら、自らの民俗研究も同時に行っている。

In 2010, Kadowaki-san finally moved from Zushi to Tokamachi after 40 years of traveling to the area. The reason for the move was to join in the Local Activation Team which has no age limit.

At first Kadowaki-san tried to move into Mino Omi's house, but this didn't work out, and eventually a move was made to a house in Sugata. Kadowaki-san started the *Jonnobi Newsletter* (Jonnobi Tsushin), an in-house magazine of the Local Activation Team.

Kadowaki-san continues to do folk research while at the same time working to create a local network system as an NPO supporter.

門脇さんの民俗資料 4　桑原光江さんの『ゆずり葉』
KADOWAKI SAN'S DOCUMENT 4 : MITSUE KUWABARA'S "YUZURIHA"

調査年月：2015年6月／調査対象：門脇 洋子（姿集落）／みんぱく研究員：深澤 孝史
Date: June 2015 / Researched: Yoko Kadowaki, Sugata / Researcher: Takafumi Fukasawa

　門脇洋子さんは、地域に根ざすミニコミ誌の保存活動も行っており、「ゆずり葉」は十日町でも大変地域に愛されたミニコミ誌として25年続いた。もともと、雪深い環境で、出稼ぎで残される奥さんたちの冬の活動としてミニコミ誌や女性の文筆活動は盛んだった。

　「ゆずり葉」は公民館の婦人学級の活動としてはじまり、桑原光江さんはその中心人物として活躍した。光江さんは民生委員でもあり、訪問の際の会話のツールとしても重宝したそうだ。市民活動であるが、徐々に規模が拡大していき、投稿者も全国に広がっていった。

　光江さんの生い立ちや時代背景も重なり、8月は戦争特集号としてページ制限を設けずに発行していた。光江さんの「戦争について本当に書いてもらいたい文章は、結局書かれないんです」という言葉が印象的だ。

　Kadowaki-san has also been working to preserve the local mini community magazines. *Yuzuriha*, named after a native Japanese plant, was well loved by the people of Tokamachi and had been published for 25 years.

　Yuzuriha was first started as a program for women at the community center, and Mitsue Kuwabara played an important part in its management. While *Yuzuriha* was originally a local effort, its scale has gradually expanded, and contributions came in from all over the country.

　Overlapping with Kuwabara-san's own personal background and era, the August issues of *Yuzuriha* were a special, larger edition dedicated to the Second World War. "However, what I would really like to have written about war were not published, in the end." Words from Kuwabara-san that leave quite an impression...

八・姿の家

門脇さんの民俗資料5 解体された織物工場のタイル
KADOWAKI SAN'S DOCUMENT 5 : THE TILES OF A DEFUNCT TEXTILE FACTORY

調査年月：2015年6月／調査対象：門脇 洋子（姿集落）／みんぱく研究員：深澤 孝史
Date: June 2015 / Researched: Yoko Kadowaki, Sugata / Researcher: Takafumi Fukasawa

　十日町市は織物産業で栄えた町だが、町の織物工場はどんどん減少していっている。門脇さんは廃業した工場の建物も文化財として保存されることを願っているが、なかなかうまくいかず、とある解体された織物工場に使われていたタイルだけをもらって保管してある。

　Tokamachi City used to be a thriving hub of textile factories, but over time more and more factories have disappeared. Kadowaki-san hopes to have these abandoned factories preserved as objects of cultural heritage, but the results have been less than promising. Kadowaki-san has kept this box of tiles from a defunct factory.

八・姿の家

門脇さんのごはん
DINNER AT THE KADOWAKI HOUSE

調査年月：2015年6月／調査対象：門脇 洋子（姿集落）／みんぱく研究員：田中 保帆
Date: June 2015 / Researched: Yoko Kadowaki, Sugata / Researcher: Yasuho Tanaka

　6月29日の晩ごはんは焼肉だった。塩こうじに漬けた豚肉（すごく柔らかい！）や、もどした麩を焼いて食べる。麩は肉汁をしみこませると美味しい。

　タレもシークァサーを使った自家製のものだし、梅干しもおうちで漬けているし、台所には保存食のビンがいっぱい。山や畑で季節のものがたくさん採れるときにまとめて作っておくそう。

　朝はおにぎりの下に採ってきたばかりの笹の葉が敷いてあった。おにぎりをほおばるとふっと笹のかおりがする。美味しい。本当に採れたてのものってかおりがよくて、みずみずしい。なかなか都会ではできない体験。食物を「いただく」ことも丁寧に生活することも大事にしているんだなぁと思う。

On June 29th, *yakiniku* for dinner. We had pork marinated in a complex mixture of salt, yeast and other fermenting agents, known as *shiokoji* (the resulting meat was amazingly tender) and grilled *fu*, which are little pieces of bread-like gluten.

The kitchen was filled with jars of preserved foods. The *umeboshi* were hand pickled and the meat sauce was homemade using *shiquasar*, a citrus from Okinawa. When the foods in the surrounding mountains and fields are in season, they are collected and preserved so they can be used all year round.

For breakfast, I found a freshly picked bamboo leaf spread underneath my rice ball. As I took a gracious bite out of the rice ball, I could smell the aroma of the accompanying bamboo leaf. It was quite a delicacy. Only newly picked leaves are this aromatic, this fresh. One would be hard pressed to experience this kind of cuisine in a big city. Gratification for the food we have, leading the "slow" life, these are truly important aspects of human life.

八・姿の家

1　　　　　　　　2　　　　3

1 - みんぱく研究員が描いたご飯の記録 | **2** - 鉢集落の郷土料理のレシピ | **3** - 肉汁を染み込ませた車麩
1 - A sketch of dinner by a *Minpaku* researcher | **2** - Recipes of Hachi Village's local cuisine | **3** - Gravy *fu* (breadlike pieces of wheat gluten)

67

田麦の家

全員「福崎」姓の田麦集落。中越地震の影響で、60軒あった集落の家も現在は30数軒になった。戦後の農地開拓によって耕された25町（約25万㎡）もの畑がある。集落の連帯が特徴。布海苔（ふのり）のつなぎによる田麦蕎麦を集落の名物として出す蕎麦屋を市街地で開いている平八郎さん、家をリゾート施設のようにDIYで改修している進さん、防災関係の仕事をするまとめ役の一久さんと民泊するそれぞれのお宅も特徴的で魅力的だ。

TAMUGI HOUSE

All the villagers of Tamugi have the surname "Fukuzaki." As a result of the impact of the Chuetsu Earthquake, there are now only 30 houses in the village, down from 60. A 25-cho (approximately 25 hectares) plot of land has been set aside for post-war development. Community ties are very strong. The specialty of the village is called Tamugi Soba. It features *funori* (a kind of seaweed) as a thickener to make the noodles *al dente*.

広域農道と根性薔薇
THE WIDE FARM ROAD AND THE GUTSY ROSES

調査年月：2015年4月／調査対象：福崎 一久（田麦集落）／みんぱく研究員：深澤 孝史
Date: April 2015 / Researched: Kazuhisa Fukuzaki, Tamugi / Researcher: Takafumi Fukasawa

着工までに40年かかった集落悲願の道路拡張と壊される家に咲く薔薇

　写真の家は1970年頃、田麦の福崎一久さんが18歳まで住んでいた家だ。18歳の時に隣に新しい家を建てたのでこの家は物置として使われるようになった。元々住んでいた家の外に薔薇を植えていたが、あまり育たなかったこともあり、新築工事の際地面をアスファルトにしてそのまま埋めてしまった。しかし薔薇はその後アスファルトを破り出て、一久さんが生まれた家の壁をつたいはじめた。

　2016年、田麦集落の長年の悲願である広域農道の工事が着工する。集落の中で枝分かれした細い道が一本の太い道路になるのだ。この道が完成することで、家の前まで除雪車が入ることができる。高齢化が進む集落では死活問題である冬の除雪の苦労がものすごく軽減する。

　しかしそのために、薔薇がつたっている物置になった家を壊すことになっている。さてさて薔薇の命運はいかにと思ったが、今度の広域農道の工事の際は、またアスファルトで埋められるのではなく、ちゃんと植え替えてもらえるそうだ。

1 - 田麦の広域農道工事計画図

九・田麦の家

THE 40 YEAR WAIT FOR THE LONG-SOUGHT-AFTER WIDER ROAD, AND THE BLOOMING ROSES OF THE BROKEN HOUSE

Around 1970, a new house was built next to the house that Kazuhisa Fukuzaki had lived in until the age of 18. Roses were planted outside the old house, but did not grow well, so when the new house was built, the ground was paved and the roses were buried. However, the roses broke through the asphalt and began to grow up the side of the house.

In 2016, the village will break ground for a wider farm road, something long sought after by the locals. The narrow branching roads that run through the village will be turned into one wide road. With the completion of this road a snow plow will finally be able to reach the gate of each house. This will significantly lighten the load for the village, with its increasing elderly population. For the elderly, removing the piles of snow from their property can be a difficult, often deadly task.

However, in order to build this new road, the house covered in roses will have to be bulldozed. During the construction of the new road, however, it seems that the gutsy roses will be replanted.

1 - The plan for the new road through Tamugi Village

空き缶炊飯
COOKING RICE IN EMPTY CANS

調査年月：2015年8月／調査対象：福崎 一久（田麦集落）／みんぱく研究員：笹田 夕美子
Date: August 2015 / Researched: Kazuhisa Fukuzaki, Tamugi / Researcher: Yumiko Sasada

　福崎一久さんのおうちに民泊させていただいた日の朝ごはんの時のこと。350mlのアルミ缶2個で釜と鍋をつくり、牛乳パックを燃料に、十日町産こしひかり1合と同量の水をいれて、ごはんを炊く方法を教わった。この方法は、中越地震の後、防災の講演会で大学の先生が地域の人に教えてくれたという。

　2004年の中越震災のとき、集落の人は全員避難所に集まった。だれがこの集落にいるのかはよくわかっているから避難者の人数、所在はすぐに確認できた。道路は土砂で通れない。しかし重機を持っている人がすぐに作業にとりかかり翌日には道路は開通していた。役場に文句をいう間もない。水は湧き水があるから困らない。食事は誰というでもなく、家にある米や野菜、常備している食料をもってくる。家の冷蔵庫は電気が止まっているから、むしろ中にはいっているものをどんどん食べたほうがよい。食事の炊き出しも、プロパンガスも、釜も、鍋もある。発電機だって持っている。田麦集落には救援物資は必要なかったから、他の避難所にまわしてくれと伝えたが、人数に応じた分配をしなくては、今後物資が届かなくなるということで、配られた冷たいおにぎりを、しぶしぶ食べたりしたという。避難生活では、食物は豊富にあり、上げ膳据え膳で年寄りは太って帰ったくらいだと一久さんはいう。

　田麦集落では、非常時に空き缶でごはんを炊く場面はまずない。防災講演会で習った空き缶炊飯を、福崎さんはこの地区に民泊にくる小学生のためのアトラクションとして活用している。

九・田麦の家

1 − 空き缶ふたつの上部を缶切りでくり抜く｜2 − 空き缶をひとつだけ側面に穴をあけコンロをつくる｜3 − コンロの缶の上に炊飯用の缶を置く

I would like to talk about a certain breakfast we had one day. He taught me how to cook some *koshihikari* rice from Tokamachi Uonuma, using only two 350 ml aluminum cans for the pot, and a milk carton as tinder.

He learned how to do this when a university professor came to the region to hold a workshop on disaster survival after the Chuetsu Earthquake (2004). During the earthquake, everyone escaped to the evacuation center. However, since the size of the village means everybody knows everybody else, it was an easy task to make sure no one was still left in the village. Landslides meant the roads could not be used, but as some of the locals owned heavy construction machinery, the roads were cleared the following day. Everybody passed out food to everyone else, since most families had a stockpile of vegetables and rice. There was propane gas for cooking, as well as pots and ovens. There was even an electric generator.

Thanks to all this, they had no need for relief provisions, and actually tried to turn down the rescue workers when they came through, saying they should deliver the aid to other villages in need. But the workers said they had to meet their quota per village, and would not be able to deliver the food somewhere else, so the people of Tamugi were stuck eating the cold, leftover rice balls.

First and foremost, the people of Tamugi will never be in such dire straits that they need to boil rice with aluminum cans and milk cartons. Fukuzaki-san is just using this skill as a parlor trick to attract more elementary students to the area's country life program.

1 - The tops of two empty cans are removed with a can opener | 2 - The cans are turned into a stove by opening a hole in the side of one of the cans | 3 - The other can is placed on top to cook the rice

バディ（犬）、懐かなかったタヌキ、玄関前のクモの巣、コイ
BUDDY, THE UNTAMABLE STUFFED RACCOON DOG, THE COBWEB OF THE FRONT DOOR, AND SOME CARP

調査年月：2015年8月／調査対象：福崎 一久（田麦集落）／みんぱく研究員：笹田 夕美子
Date: August 2015 / Researched: Kazuhisa Fukuzaki, Tamugi / Researcher: Yumiko Sasada

福崎一久さん、奥さんの陸子さん、一久さんの両親の英一さん、カンさんのおうちに民泊した。このご一家はとにかく、育て上手。3人の息子さん、ラブラドールのバディ、数々の野菜、お米、玄関前の花、お庭の花の肥料が流れて、そのまわりの草花も豊かに育っている。玄関前に巣をはるクモにまでその愛情は及んでいた。

サイドボードの上にはタヌキの剥製が立っている。これは以前、畑で罠にかかったタヌキで、ドラム缶のなかに入れて飼っていたそうだ。おじいちゃんの英一さんが「タヌキは懐かないなぁ。餌を入れてやっても毎回、シャーと牙を剥く」とつぶやく。「それでも、うしろからそぉーっと撫でてやったら、そのうちそのままじっとしていて嫌がらなくなったなぁ」と。

子どもや人、犬に限らず、罠にかかったタヌキからクモやコイにいたるまで生活の端々に大事に思いをかけている。

そして私自身もこの家にきて、なんでこんなにと思うほどかわいがっていただき、年齢を忘れ、夏休みにおじいちゃんの家にきた孫のような気分ではしゃいだ。

For my visit, I stayed with the Fukuzaki family; Kazuhisa, Mutsuko, Eiichi, and Kan. This family is particularly good when it comes to "raising." Be it children or vegetables, they pull out all the stops and hold great importance to "raising." They aren't stingy when raising their three sons, their Labrador Buddy, or their many vegetables and rice.

On one of the low shelves is a stuffed raccoon dog. They caught it in their rice fields and raised it as a pet in a drum can. Grandpa Eiichi said, "You can't tame raccoon dogs. Every time I went to feed it, it would always growl and show its teeth. However, if you went up behind it real slow and started petting it, it wouldn't run away or get angry." The kindness of the Fukuzaki family is not just limited to people and their pets, but to the raccoon dogs caught in their traps, to the carp fish in their ponds, to every aspect of life, including myself.

I was lucky enough to be bathed in the kindness of this family, so much so that I was able to forget my age and feel once again like I was a little child traveling to the country side to visit my grandparents.

九・田麦の家

1 - 愛犬バディは夜は一緒に布団で寝る｜2 - タヌキは越冬する前に絞めて剥製にしてしまった｜3 - 1年以上かかっていた蜘蛛の巣はその後見たらなくなってしまった　1 - Their beloved Buddy sleeps with them at night｜2 - This raccoon dog was killed and taxidermied before passing the winter｜3 - It took the spider over a year to spin the web, but it disappeared before anyone noticed

福崎進さんのDIYな家と生活
SUSUMU FUKUZAKI'S DIY HOME AND LIFESTYLE

調査年月：2015年8月／調査対象：福崎 進（田麦集落）／みんぱく研究員：藤田美緒
Date: August 2015 / Researched: Susumu Fukuzaki, Tamugi / Researcher: Mio Fujita

　庭一面の芝生、ハンモック、家族写真を入れる額、テラス、ベランダ、ピザを焼く石窯、有機野菜の畑……。福崎進さん・美恵子さんのお宅は、進さんお手製のものたちであふれている。

　建設会社にお勤めの進さん。仕事柄、余った木材や芝生を手軽に入手する機会も多く、それらを有効利用して自ら造るのだそう。実は長年そのような暮らしをしていたわけではない。美恵子さんと結婚してすぐ、進さんは単身赴任で全国を飛び回り、ほとんど集落に戻る機会がないまま30年以上がたった。ようやく最近になり我が家でゆっくりできる時間ができ、自宅の改造にのめり込んでいったとのことだ。

　家族想いのお二人にとって、DIYとは、家族の幸せを模索した先に偶然あったというだけなのかもしれない。だから肩肘張らずカッコイイ。「心を満たすものはお金では解決できない。だから自分で出来ることは自分でやる」とおっしゃる進さんは、きっと今日も田麦の家で夢を造っているだろう。

1

A grass covered yard, a hammock, a frame for family photos, a terrace, a balcony, a stone pizza oven, and an organic vegetable garden; the house of Susumu and Mieko Fukuzaki contains many of Susumu-san's hand-made creations.

　Susumu-san works at a construction company. Because of his job, he is easily able to get a hold of extra wood and turf, which he uses to build his own things. But before, he was very busy to travel for business around Japan, so he could not spend his time with his family.

　For these two, D.I.Y. was probably just a natural result of their continued efforts to create a happy home. This makes them a naturally cool couple. "You can't satisfy your soul with money. So, if you are able to do something, you should do it" said Susumu-san, who even today is doubtlessly still feeding his dreams in Tamugi.

2

3

九・田麦の家

1 – 母屋と倉庫を空中回廊でつなぐ | 2 – 移動式ピザ釜 | 3 – 原付の荷台にロックスターのロゴを模した屋号のプレートが取り付けられている　1 – The storehouse is connected to the main house via a corridor | 2 -The mobile pizza oven | 3 - A house name plate with a rock star logo design is attached to the motorcycle trailer

75

進さんの還暦祝い写真
A PHOTOGRAPH OF SUSUMU'S 60TH BIRTHDAY

調査年月：2015年8月／調査対象：福崎 進（田麦集落）／みんぱく研究員：小田 弥生
Date: August 2015 / Researched: Susumu Fukuzaki, Tamugi / Researcher: Yayoi Oda

　進さんの還暦のお祝いに二人の娘さんが定番の赤いちゃんちゃんこではなく進さんのイメージに合ったかたちで記念写真を撮影したいと、赤のラルフローレンのセーターをプレゼントした。赤が際立つよう娘さんたちと奥さんの美恵子さんは白で囲むようにプロデュース。自由で自然なのびのびした表情のご家族が映し出されている。

　家族のつながりがとても強く、娘さんはお父さんの進さんとお電話で1時間話すこともあるそう。そしてこの日は次女の娘さんの留学出発前でしばしの別れの前に撮影したものなのだとか。ガラスは美恵子さんが選び、額はガラスに合わせて進さんが作られたもの。風習も工夫とアイディアをかけることであらたなかたちの発見や思い出は深くなるものと感じた。家族の合作といえる写真である。

For Susum-san's 60th birthday, his two daughters decided not to go with the traditional red vest used for the occasion, but rather opted to take a picture that was a bit more in line with their father's style. So they bought him a red Ralph Lauren sweater, and sported white shirts, along with their mother, for the commemorative picture. The picture perfectly reflected this families' free and natural nature.

The Fukuzakis are a very close family, and the daughters talk to their father on the phone for an hour on end. For the frame, Mieko-san chose the glass, and Susumu-san built the frame to match the glass. Even with this tradition, you could really feel the family's efforts to make it a lasting memory through unique adjustments and ideas.

九・田麦の家

ブルのポスター
THE BULLDOZER POSTER

調査年月：2015年8月／調査対象：福崎 キヨノ（田麦集落）／みんぱく研究員：深澤 孝史
Date: August 2015 / Researched: Kiyono Fukuzaki, Tamugi / Researcher: Takafumi Fukasawa

　このポスターを描いた大輔さんは、福崎平八郎さんとキヨノさんのお孫さんで、現在は東京の大学で勉強中。このポスターは、彼が小学校1年生のときに描いたものだ。
　とにかく重機が好きすぎて、その頃にはなんと隣の家のユンボを操縦していたとのこと。この地域ではちょっとした事故ではJAFを呼ぶなんてことはせず、ちょっと崖から車を落としても自分たちでなんとかしてしまう。そんな私も車を半分落としてしまい、助けられたのだった。

　This poster was drawn by Heihachiro's grandson, Daisuke, who is presently studying at a university in Tokyo. Daisuke drew this poster when he was a first grader in elementary school. Back then, even at such a young age, he was known to pilot the neighbor's excavation machine!
　As you can guess, he was quite a fan of construction equipment. In this region, there is no calling the Automobile Federation for something like accidentally driving off the road. They make do with what they have and help themselves. Consequentially, they helped me when I accidentally drove off the road during my visit.

九・田麦の家

原（蕎麦と戦後開拓と縄文土器）
HARA (BUCKWHEAT, CULTIVATION AFTER THE WAR, AND JOMON PERIOD POTTERY)

調査年月：2015年6月／調査対象：田麦集落／みんぱく研究員：深澤 孝史
Date: June 2015 / Researched: Tamugi Village / Researcher: Takafumi Fukasawa

終戦後、出土される縄文土器を鍬で割り、農地開拓を選んだ土地

田麦集落の上には「原」という面積が25町（1町＝約1万㎡）の農地がある。現在もここでたくさんの蕎麦や米、野菜などを育てている。現在80歳を超える福崎平八郎さんは、ここで育てられた蕎麦を50代後半になってから田麦蕎麦として名物にし、工場と店を開いた。田麦蕎麦は十日町特有の作り方※を基本にしており、さらに食べる時に蕎麦つゆにわさびではなく、からしをいれるのが特徴だ。

原は戦前はほんの一角だけが農地だった。戦後の食糧難対策として全国的に農地開拓が行われた。5年以内に開墾した土地は所有することができたので、田麦の人たちも雑木林だった原を必死で耕した。

開拓時、原の一部では掘ると縄文土器や石器が出土したが、当時の開拓者たちは鍬で割ってなかったことにしたそうだ。いざ発掘されるとなんの補償もないまま何年も国が調査に入るので、開拓を止めなければならず、住民の死活問題となってくる。

もちろん文化財を割ることは法律違反だが、単純に責められる話でもない。土器はある意味すでに死んでいった人々の民俗文化だが、それを残すために今生きる人たちが苦しむのは本末転倒でもある。文化について考えるとき、残す文化と築く文化と両方の側面がある。「縄文土器を割り、畑を耕すという行為」も事実である以上、近代の無形文化のひとつなのだろう。

※十日町で食される蕎麦は、布海苔（ふのり）という海藻をつなぎに使う。織物が盛んだった当時、生地の糊つけに使われていた布海苔が偶然蕎麦の中に落ちたことがきっかけで使われるようになったといわれている。

1 - 原で行われていた野点蕎麦のイベントの写真

九・田麦の家

AFTER THE SECOND WORLD WAR, BREAKING THE JOMON POTTERY WITH A HOE, AND THE LAND CHOSEN FOR AGRICULTURAL CULTIVATION

Just above Tamugi Village is a piece of farmland called "Hara", that is 25-cho (in size 1-cho = approximately 1 hectare). Lots of vegetables, buckwheat and rice are raised on this farmland. Heihachiro Fukuzaki opend a factory and a restaurant of the buckwheat noodle, and promoted "Tamugi Soba" as specialty of the village.

Before the Second World War, only a small corner of Hara was used for farming, but after the war, a countermeasure to develop farmland all over the country was put in place to fight the food shortage. Within 5 years of Hara's development, locals could own their cultivated land. While digging in Hara during the cultivation, locals discovered pieces of Jomon period pottery. The discoverers quickly destroyed the pottery with their hoes and pretended that nothing had happened. Had they reported the find, then the state would have done a lengthy survey of the area. This would have stopped the cultivation of the new farmland and could have become a matter of life and death for the locals.

Of course it is illegal to willingly destroy a cultural heritage artifact, but the diggers cannot be so easily blamed. True, the pottery was a piece of folklore from a people long deceased, but to preserve such an artifact at the expense of those presently living in the area is a bit like putting the cart before the horse. When contemplating cultural issues, you must address both those left behind and those that will exist henceforth. "To break an artifact in order to plow a field" is itself, in a way, a type of intangible cultural property.

1 - Pictures from the buckwheat noodle picnic party

民泊レポート
HOMESTAY REPORT

民泊レポート① 田麦　福崎一久邸（8月1日〜2日）

みんぱく研究員　太田 清美

　とにかく濃厚な2日間でした。生まれも育ちも、名古屋。両親の出身も名古屋。帰省すると言っても、自転車で20分くらいで行けてしまいます。そんな私は、田舎への憧れを持っています。「田舎に泊まる」という某TV番組があったと思いますが、自分も行ってみたいなぁと思っていました。

　なので、今回、みんぱく研究員の募集をみて、迷わず参加しました。研究員ということなので、しっかりと目的を持って。私は、「実際に、どんな生活をされているのか」「その地域に根付いている文化、引き継がれてきたことなどを知る」ことを目的としました。

　受け入れてくださったお宅は、六箇地区振興会会長さんのお宅。面倒見のよさそうなお父さんは、お話好き、お酒好き、愛犬大好き。中学の同級生だというお母さんは、家事の手際よく、温かい目で家族を見守る。84歳のおじいちゃんは、今も軽トラで畑や田んぼに出かける。90歳のおばあちゃんも現役。6歳のラブラドールレトリバーちゃんもいる。皆さん、おもてなししてくださり、居心地よく、「夏休みに田舎へ帰ってきた」という感じ。もしくは「おもひでぽろぽろ（ジブリ映画）の世界の中にきた！」という感じ。

　あやうく、普通に遊びにきたのと勘違いしてしまいそうでした。が、そんな中で、研究員として見てきたことをレポートしていきます。

2015年に取り壊される公民館に取り付けられた集落名看板
The village name plate attached to the community center to be demolished in 2015

田麦蕎麦を食す英一さん、カンさん
Eiichi and Kan eating Tamugi Soba noodles

おもてなし料理から暮らしの豊さを感じる

　夕食の豪華さ！というか、豊さ！なのです。どんな内容だったかというと、自分たちの畑で採れたお野菜、山の中で採れた山菜などなど、ほとんどが、家の近くで手に入ったもの。お水も湧水。お米も田んぼで。なんでも揃うのです。そして、お野菜の味がしっかりして美味しい。この地域のお祝いのときやみんなが集まるときに出す料理。くじら汁、えご草、なますり、夕顔、ぜんまい、棒鱈の煮つけ、などなど、名古屋では味わえない料理をいただきました。

　丁寧な暮らしぶりも感じられました。とにかく、私たちに嬉しそうに紹介してくださる姿から、おじいちゃんが作物を大切にしていることが感じられるのです。そして、誇りに思っているということも。
「厳しいおやじに仕込まれたんだ」
「さつまいも畑は、20年連作しているんだ。そこの畑は連作しても大丈夫で、そこの畑だから美味しくできる」
　このさつまいもは、近所に配るのだそう。何百個も。
「モロッコ豆は今はさやごと食べるけれど、もうしばらくしてから収穫すると、中の豆を食べられるんだ」
と話すと、立ち上がってどこかへ。10分くらいたつと、懐中電灯を持って

えご草（海藻をゼリーに固めたもの）
Ego seaweed (seaweed solidified into jelly)

棒鱈（ぼうだら・鱈の干物）
Boudara (dried codfish)

民泊レポート① 田麦 福崎一久邸

お祝いのときのさつまいもの断面はギザギザに切る
Sweet potatoes with the section jaggedly cut for celebration

モロッコ豆
Morocco beans

手作りの笹団子
Homemade bamboo leaf *dangos*

わらびの灰汁（アク）を抜くために重曹をかける
Baking soda is added to remove the bracken lye

帰ってきます。手には、マーブル柄の豆がたくさん入った袋と、えんじ色の豆が入った袋。
「これがモロッコ豆で、こっちが小豆」と。
　食事の最後には、手作りの笹だんごが。お母さんとおじいちゃんとで600個作ったって！！！
「えっと、それは売るんですか？」と聞くと、当たり前のように「いや、全部配った」とおじいちゃん。
　うーん、その数を配るって、想像できない。おじいちゃんの性格なのか、土地柄なのか。両方かな。それにしても、ストッカーを3つも持つおじいちゃん……。

　食事のあと、話をうかがっていると、この地域には、保存食を作る習慣があるとのこと。"あんぼう"というものもあるのだそう。米の粉をこねて時期の野菜、山菜、小豆などをあんの具にしたものだそうです。雪深い冬を越すためのいろいろな知恵があるのだろうな。
　笹のむき方を教えていただきました。小豆もおじいちゃんの育てたもの。美味しい！
　夜遅くまで、お酒好きなお父さん、お酒を味わうおじいちゃんとお話。新潟の美味しいお酒と美味しい湧き水でいただくお酒。贅沢です。
　最後の最後に、おじいちゃんひと仕事。採ってきたぜんまいの灰汁をぬくために、お母さんがお湯を沸かし、おじいちゃんが重層を入れる。その加減は、おじいちゃんのさじ加減なのだな、と。お母さんも、おじいちゃんのさじ加減を大切にしているのだな、と感じました。

雪国の住宅と豊かな暮らしは震災にも強かった

　豊かな恵みに感激し、夕食をいただきながら、2004年に起きた新潟県中越地震のときの話をしていただきました。
　ちょうど断層の上に建っていたためか、一久さんのお宅は、とくに被害をうけたそうです。"全壊"の扱いでした。家にひねりを入れられた感じだったそうです。でも、ぐしゃりと倒れることはありませんでした。雪国の住宅、特に新潟の雪は水分を含んで重いので、その重い雪に耐えられるように太い柱が使われています。そのため、ぐしゃりと倒れることはなく、組み立て直し、再建できたとのことでした。
　避難所での生活の話もしてくださいました。避難所では、次の日から、すぐに炊き出しがはじまったそうです。お野菜、お米は、自分たちの家や畑にあり、水もある。ガスは、プロパンガス。自家発電もできる。道路だって、多少の重機を持っているので、自分たちで直してしまう。行政の助けが来る前に、自分たちの力で避難生活、復興をしていったそうです。

民泊レポート①　田麦　福崎一久邸

「役場が持ってきた食料は、申し訳ないけど、いらなかった」
「医療チームもついてくれて、高齢の方にとってはいつもより食事もとれて、安心した生活だっただろう」と。
　なんと、たくましいことでしょう！ 名古屋の生活を思うと、まず、水に困るだろう……きれいな水があるということは、こんなに強いのか……と思わされました。それに、普段から、お野菜の分け合いをしながら暮らしていたり、地域の人たちの繋がりがある。助け合う精神が、自然に根づいているのだろうな、と。
　そうした小さなコミュニティの中でも、避難生活では、人の嫌な面も垣間見たそうです。それでも、やはり、もともと繋がりのある人のそうした一面をみるのと、全く知らない人のそうした一面をみるのとでは、違うと思うのです。雪国の生活の知恵や、豊かな暮らしは、いざというときにも強い！ ということを感じました。

" 暮らしの豊かさ、丁寧さ ＝ 強さ、たくましさ "

　泊物館に展示できるものを、と思いましたが、選ぶことができませんでした。ここでの暮らし、人の知恵、代々引き継いできたもの、自然、ここにある全てが展示すべきものだったのです。私の中では、「モノ」ではないものでした。
　以前から思っていました。高齢の方から、いろいろな知恵を学びたい、身に着けたい、と。すでに自分の祖父、祖母はいないので、意識して近づかなければ学べません。繋がりの強い地域では、自然と伝わっていくものなのだろうな、と感じました。おじいちゃんのさじ加減など。
　山の上の方へあがり、田んぼ近くの湧き水を汲みに行った帰り道。こうした地域をまるっと残していきたいと思いますが、「若い人たちは戻ってきていますか？ 戻ってきてほしいですか？」という私からの問いに対するお父さんのコトバが胸に残っています。
「こんなに大変なところに田んぼがある。自分もまだ兼業農家だ。こんなところに戻ってきてほしい、残ってほしいなんて言えないでしょ」
「都会は、便利でしょ」
　暮らしている人にしかわからない言葉だな、とぐっときました。
　どうなっていくのか、どうなっていくのがいいのか、わかりません。でも、少しでもこうした暮らしに触れたり、知る人がいて、何かを感じていくことが大切なのかな、とただ2日間いただけの私の感想です。
「いつでも遊びにきてください」
と言ってくださったのがとてもうれしかった。
　また遊びに行きます！

湧き水は冷蔵庫に入れていた水よりも冷たく、そのまま田んぼに入れると稲が育たないため、いったん池にためる
The spring water is colder than refrigerated water, and so must be warmed up in a nearby pond before it can be used in the fields.

湧き水の口
The mouth of the spring

200年代々受け継がれてきた蕎麦切包丁
The buckwheat noodle knife handed down for 200 years

福崎隆造さんのトマト栽培のビニールハウス
Ryuzo Fukuzaki s tomato green house

まとめの続きのような番外編

　こんなに豊かな暮らしの中で、昔と変わったところはあるのだろうか。そう思って質問をしてみた。
「昔と変わったところはありますか？」
　しばらく考えてから、
「クマやイノシシが増えたなぁ…」
と、ぼそっとおじいちゃん。
　ここ数年、クマやイノシシ、タヌキ（ハクビシンが多いらしい）が増えているそうだ。里山では、どこでも同じ悩みを抱えているのだな。
「原因は、山を切り崩してきたこと」
「住む場所がなくなって、みんな峠を越えてくるんだ」
「お互いにちょうどいい暮らしができていればよかった」と。
　この数年、暮らしの豊さが見直されている。今回、まさにそれを感じた。ここでの暮らしは、実は、最先端の暮らしなのではないか。資本主義経済の中、たくさんのモノが作られ、売り買いされ、そうした流通システムの上に成り立ってきた今の日本。それを続けていく、増やしていくしかないと思う人たちがいて、山を切り崩していく。追われる動物たち。追われた動物たちが向かう先にも人がいること、暮らしがあることまで考えが及ばない。便利な暮らしがいいだろう、と都会の暮らしに慣れていく子どもたちに、戻ってきてもらうことは期待していない。10数年後、ここは、動物たちだけの楽園になるのか、それとも、共に生きる場になるのか。

民泊レポート② 小荒戸 五十嵐茂義邸（8月15日〜16日）

みんぱく研究員 中田一会

「その家の前には、"赤いふんどし"がたくさん並んでるんです。すぐわかりますよ〜」
「えっ？」

　みんぱく・深澤館長のざっくりとした説明に導かれ、松代・農舞台近くの小荒戸集落にやってきたのはお盆の8月15日。館長の言葉通り、"赤ふん"をはいた彫像が並ぶ場所に、今回民泊させていただいた五十嵐さんのお宅がありました。

　お邪魔して早々、近くの温泉「雲海」の絶景露天風呂に浸かり、江美子さんによる郷土料理をご馳走に。

　楽しい！美味しい！……と、のびのびしていたのもつかの間のこと。20時前になると茂義さんが立ち上がりました。

「さ、浴衣を着て着て！盆踊りがはじまっちゃう。向こうでビールを飲まなきゃ！」

関根哲男《帰ってきた赤ふん少年》（2009年）　五十嵐さんはこの作品の管理もずっと行っている
"Boys in Red Loincloths Returned" (2009) by Tetsuo Sekine; kept intact thanks to the efforts of Mr. Igarashi

小荒戸の盆踊り大会に「祭り」の最小形を見つけた夜

　そう、この日は、小荒戸集落の盆踊り大会。五十嵐家から徒歩2分の丘の上が会場です。小荒戸の盆踊り大会は、シンプル！

　櫓の回りを、20数戸の住人と帰省してきた家族たちが囲んでいました。参加者はだいたい50人ぐらい。住人による住人のためのお祭りです。流れるのは松代伝統の節。今は昔のような歌い手がいないとのことで、1曲ループの音楽が再生される中（しかも途中でおじさんたちの雑談も録音されている、笑）、ゆったりとした動きで輪を描き、踊っていました。

　お祭りの運営を担うのは全て集落の人々。ある一家は焼き鳥係。無料で焼き鳥食べ放題、缶ビール・缶チューハイも飲み放題というのだから驚きです。たまにはみんなで集まって踊って飲んで食べよう、ということですね。そんな大事な夜に、お邪魔してしまって嬉しいやら、ちょっと申し訳ないやら。でも皆さん珍しがって話しかけてくださってほっとしました。

　ところでこの盆踊り、みんぱく研究員の二人は、なかなか上手に踊れません。振り付けはシンプルなのに……1曲しかないのに……研究員に踊りのセンスが無い！

　あまりの不出来さに、「足の払いが難しいのよね」「あの人をお手本にするといいよ」などなど、声をかけてくれる小荒戸の方々の優しさが心に沁みました。嗚呼、踊れる人に生まれたかった。

　でもゆらりゆらりと曲に乗りながら櫓をまわり、間の手を一緒に唄ってみたりするだけでも、凄く気持ちいいんです。

小荒戸盆踊り大会会場
The bon festival dance at Koarato

焼き鳥係の一家　無料で焼き鳥食べ放題、お酒も飲み放題
All-you-can-eat *yakitori* and all-you-can-drink alcohol from the family in charge of *yakitori*

民泊レポート② 小荒戸 五十嵐茂義邸

突然はじまった「全員あたるくじ引き」

　そして、ようやく振り付け覚えてきたかも……というタイミングで、突然の盆踊りタイム終了。「もっと踊りたかったのに……」と嘆くと、近くのおじさまが「1時間で十分。あとちょっとって思えるぐらいが丁度いいの」と教えてくれました。なるほど！

　ここからは、お楽しみのくじ引き大会のはじまりです。踊っている間にそれぞれが引いたくじ。番号を待っていると……
「25番！はい、おめでとう」
「18番！はい、おめでとう」
と、くじ引き係が番号を読み上げてくれます。
「わーい、当たった！」
と喜ぶ研究員・黒部。わたしは35番。そわそわしていると……わさびが当たった……！まさかのわさび……！！
「カタカタ音がするよ」
「なにこれ、ジュエリーなんじゃない？」
と煽った面々は、包みを開けたところで大爆笑。そう、小荒戸のくじ引きの賞品は、ぜんぶささやかな日用品だったのです。

　小荒戸のくじ引きには、アタリもハズレもなく、参加者全員が当たる仕組み。某デパート風だけどよく見ると全然違う包装紙も洒落が効いていて素敵。

　小荒戸の盆踊り大会に参加して、わたしたちは「お祭りに必要なモノ」の意識を改めました。

　1曲ループ再生の盆踊り、1種類だけの焼き鳥、手持ちの花火、そして全員あたる小さなくじ引き。こんなにミニマムな形でもお祭りって楽しいんだ！凄い！……と、大変感激したので、「小荒戸の盆踊りの全員あたるくじ引き」（P.46）を収蔵品のひとつに選ばせていただきました。

五十嵐さんのアートマネジメントを肴に飲む

　祭りは終わっても、小荒戸の夜はまだまだ終わりません。浴衣から着替えて再び五十嵐家の食卓を囲むわたしたち。五十嵐夫妻の歩んできた道、日頃の過ごし方、芸術祭と地域の関係などなど濃い話を肴にお酒をたくさんいただきました。この日は飲んだ……飲みましたよ……。

　五十嵐さんのお宅はもともとお豆腐屋さん。かつては、冠婚葬祭がある度に油揚げを大量につくっていたんだとか。いなり寿司、本当に美味しかった！

踊っている間にそれぞれが引いたくじ
The lottery numbers drawn while dancing

中田研究員があてた生わさび
The tube of *wasabi* won by researcher Nakata

手作りのいなり寿司
Homemade *inari sushi*

民泊レポート② 小荒戸 五十嵐茂義邸

なかでも、興味深かったのは、茂義さんによる芸術祭でのボランティアの話。アーティスト、地域住民、行政をつないで、祭りを自分たちのものとしてしっかり受け止めようという茂義さんの姿勢は、アートプロジェクトのマネージャーのお手本のよう。

実は、今回のみんぱく研究員である中田と黒部は、かつて美術大学で一緒にアートマネジメントを学んでいた同級生です。12年前、はじめて大地の芸術祭を訪れたときも一緒でした。

卒業後はそれぞれ違った道を歩んできましたが、アートプロジェクトや創作ワークショップ、アーティストとモノゴトを作り上げて行く際の裏方の仕事の大変さは学生時代にそれなりに味わっていて、茂義さんの言葉は、過去を遡って響きました。

あまりに感動したので、ふたつ目のみんぱく収蔵品は「五十嵐茂義流アートマネジメント名語録」（P.48）として、名語録をつくらせていただきました。

車とラジオ体操、朝の作品点検、そして押し花……！

わずか1泊2日のみんぱく体験でしたが、五十嵐家と小荒戸集落で過ごしたときのエピソードは濃厚すぎて、いくら書き起こしても足りません。さすがに長くなりすぎたので、最後はダイジェストでお届けしますね。

翌朝のラジオ体操。盆踊りよりは、ついていける。ラジオ体操の音源はなんとカーラジオ！バッテリーが上がってしまって、このあと2台目が登場します。

体操が終わったら、みんなで集落内の散策道へ。散歩の終着点は、今年の大地の芸術祭作品。アーティスト・キジマ真紀さんと住民による神社のインスタレーションを点検。小荒戸の皆さんがワークショップでつくった鳥はどれもクオリティが高い……！芸術祭ごと、アーティストと共同制作に挑む集落の人々は確実に腕を上げているのでしょう。

その後、五十嵐家の畑で野菜収穫をさせていただいたり、屋根裏に上がらせていただいたり、押し花作家の江美子さんに、押し花でつくるしおりワークショップを開いていただいたりしました。なんて贅沢な民泊体験。本当に感謝の言葉しかありません。

芸術祭に行かれる方は、ぜひ小荒戸集落へ！なお、五十嵐さんのお宅も含めて、松代エリアでは「おやっこ村」という年間をとおして民泊を受け入れる活動を展開されています。

2003年の大地の芸術祭にはじめて訪れて以来、2006年、2012年、2015年……と4回目の訪問だった越後妻有。でも、土地の人や暮らしにしっかり触れたのは今回が初めてでした。民泊って凄い体験

再び五十嵐家の食卓を囲む
Returning to the Igarashi dinning table

集落で行うラジオ体操
Radio exercises in the village

音源は車のカーラジオ
Using the car radio for the sound

キジマ真紀《鳥と小荒戸の物語》（2015年） 作家が集落のみなさんと制作
Maki Kijima's "A Story of Birds and Koarato" 2015. Created with the villagers

民泊レポート②　小荒戸　五十嵐茂義邸

五十嵐さんのお宅の窓から眺める赤ふんの風景
The window of the Igarashi house commands a great view of the "Boys in Red Loincloths"

です。アーティストと観光客が定期的にやってくる山村、豪雪地帯の厳しい自然。めまぐるしく変わるものと、ずっと変わらないものの両方の中で暮らし、嬉しいことも困ったことも全部引き受ける五十嵐さんご夫妻の「つき合い方」にはたくさんの学びがありました。

おまけ：五十嵐さんのお宅からは今日もきっと"赤ふん"が見えていることでしょう。

民泊レポート③ 昭和町 樋口守雄邸（8月25日～26日）

みんぱく研究員　長津 結一郎

　16時集合。まずは温泉、と案内されて、樋口守雄さんのお宅に着いたのは17時半すぎ。樋口さんは奥さまを亡くされて以降10年以上お一人暮らしというが、今回は隣人の関口美智江さんご夫妻とその甥っ子も迎えてくれる。あいさつもそこそこに宴会スタート。なにしろスケジュールが詰まっているのだ。

　早速「いただきまーす」と、ちゃんこ鍋。鶏ガラから煮込んだ本格ちゃんこ鍋は絶品。東京の相撲部屋でも何度も鍋を作ったことがあるという。

　そう、樋口さんは、力士の着物を卸す仕事を長年されてきた方。部屋の片隅には「十日町場所」と書かれた番付表。勧進元（相撲用語で「主催者」という意味）に樋口さんの名前が。小さいときに相撲ファンだった私、なんとなく血が騒ぐ。

　あっという間に食べてしまうちゃんこ鍋。おかわりも作っていただいて、ちょうど半分くらい食べ終わったところでひとまず時間切れ。急いで樋口家を後に。

　向かったのは十日町市の商店街。この日は「十日町おおまつり」というお祭りで、大民謡流しがあるという。わけもわからず浴衣を借りて着替えて、夜の街へ。

　道路が歩行者天国になっており、たくさんの人が並んでいる。「中心商店街活性化」という看板を持って立っている人がいる。地元の人たちに紛れ込んでしまい、すこし居心地の悪さを感じつつも、すぐに打ち解ける。なんと、ここに並んでいる人たちは、ここ在住の方たちが半分くらいで、大地の芸術祭の関係者の方や、市庁舎の分館を立てる計画でまちで活動している建築事務所の方など、よそからきた人たちも多かったのだ。ちょっぴり安心。時折、大きな行灯のようなものが大勢の人に担がれてすれ違っていく。そのうちに、誰からともなく踊り方のレクチャーが始まる。踊るのは、「十日町小唄」と「深雪甚句」。いずれもシンプルな踊りながら、なかなか完璧に踊れるようになるのに骨が折れる。

　と、アナウンス。いよいよ始まりだ。音楽がスピーカーから流れてくる。みんななんとなくあわせながら、じり、じりと、すこしずつ前に進んでいく。大きな交差点に差し掛かると、右から左から同じように踊っている人たちが見える。こんなに大勢いたのか！とここではじめて全容を知り、たいそう驚く。左に折れ、直進するが、せまい対向車線のようにすれ違い、踊りながら通り過ぎるチームたち。よく看板を見ると、地元の学校、踊りの教室、銀行、一般企業、議員さんなんてのもいる。みなさん毎年やっているのだろう、踊りがなかなかにそろっている（このころは中心市街地活性化チームも踊りを覚え、だんだんそろってきていた）。「十日町小唄」を2回、「深雪甚句」を1回やったところで、雨もパラついているということで時間切れ。拍手で幕を閉じる。

守雄さんが相撲部屋で作り方を学んだ鶏ガラちゃんこ鍋
Morio learned how to make chicken soup *chanko nabe* in the sumo-beya

8月の終わりに毎年開催する十日町おおまつり
The annual Tokamachi Oh-matsuri festival at the end of August

中心市街地活性化チームとしてみんぱく研究員も参加させていただく
The Homestay Researchers take part in the festival via the City Center Revitalization team

民泊レポート③　昭和町　樋口守雄邸

　その後、すこしだけ中心市街地活性化チームの打ち上げに同席させていただき、浴衣をほどき、再び樋口さんの家へ。残っていたちゃんこ鍋。甥っ子と関口さんの旦那さんはもう寝てしまったらしい。しかし新たに登場した日本酒「松乃井」。これがまた美味しいんだ。お腹がいっぱいなのにまた食べ始める。樋口さんも饒舌に話す。樋口さんは北海道生まれで私と同郷でもあり、ローカルトークをしたり、相撲の話、仕事の話、十日町市の話と切りがない。とろけるような日本酒ですっかりぼんやりとする。気持ちのよい時間。ちゃんこ鍋もいつのまにか空っぽに。そろそろ寝ますか、と23時半。布団を敷いておいた2階であっという間に就寝。

　朝6時15分起床。普段夜型の私にとっては考えられない時間。急いで身支度をして、6時30分には居間へ。朝ごはんが登場。たらいいっぱいのお赤飯。金時豆で炊いてあり、豆の色だけで色付けているのが見ただけで感じ取れる。もち米もつやつやしている。こ、これは美味しそう。しかし量がものすごい。付け合わせもなにやらすごく美味しそう。
　本当は朝ごはんの前に農業体験で、収穫した野菜をそのまま朝に食べる予定だったというが、前日の強風と悪天候で叶わず残念。でも、いただきまーす、と食べてみたこのお赤飯がまためちゃくちゃ美味しいんだ。樋口さん本当にありがとうございます。朝なのにおかわりしてしまう。
　ここで樋口さんとはお別れ。朝食の食器を片付けようとすると、
「いいんです、こちらも順序がありますので」
　と固辞する樋口さん。イケメンすぎるその配慮に甘え（昨日も夕食の片付けで同じことを言ってたなと思い返しつつ）、記念撮影をして樋口さんとはお別れ。またぜひお目にかかりたいなと思いつつ、お向かいの家へ。
　お向かいの家は、関口さんが運営しているスペース「ねころんだ」。引きこもりの人たちやその家族を支援するスペースで、モノをつくったりのんびりしたりして過ごせる場所。元オフィスだったのか、なかなか広いスペースで、開放感がある場所。
「床も自分たちで貼り直したんです。今度商店街の産業文化発信館（民俗泊物館の会場でもある「いこて」）で展示会をやるんです」
　と、関口さんの声もはずむ。

　次に向かったのは関口さんの生まれ故郷。関口さんは十日町市の星名新田と呼ばれた地域で長く暮らしていた。大地の芸術祭で言うと「光の館」の近く。その地域まで車で向かう。途中、「耕作者及び地権者以外の通行を制限します」という看板と、鎖のかかった場所が。

小豆ではなく金時豆のお赤飯
Red bean rice made from *kintoki* beans, instead of the normal *azuki* beans

民泊レポート③　昭和町　樋口守雄邸

しかし関口さん、おもむろに下車して鍵を開ける。その奥まで車は進む。窓を開けていたら枝が入り込み、車のボディを植物が削る音が響く。いまはもう消えてしまったこの集落では、いまでも耕作だけは行われ、二人の農家さんが田んぼを見ているという。

ざくざく進むと、山と山に囲まれて、突然開けたところに棚田が現れた。秘境、という雰囲気満載。青空も映え、田んぼがキラキラとしている。本当に美しい風景。関口さんは、ここに田んぼを作るために行った治水工事のことなどを、歩きながら紹介してくれる。

そして関口さんがお住まいだった家の跡へ。もういまは、家の裏にあったという池と、普段から使っていた井戸しか残っていないという。
「ここは台所で、ここはお風呂で」
と、語る関口さん。しかし私たちには何も見えず、ただ草原が広がっているだけ。歴史の積み重なりと、視点の異なりが交差して、なんとも不思議な気持ちになる。

池にいまはカエルが住んでいて、愛らしい姿を見せてくれていた。と、おもむろに、ふたがされている井戸を開けようとする関口さん。とたんに飛び出す物体たち。ん……これは……と確認するまもなく逃げ惑う一行。

よく考えたら車の中で言ってたじゃない、スズメバチが巣を作ってるみたいなのよって！なのにどうして車止めた時に窓閉めなかったの！なんで井戸開けちゃったの！スズメバチの大群が、怒っている様子で、私たち一行に向かってくる。おおあわてで車に逃げ帰り、窓を閉め、すかさず発車。あーほんとうにびっくりした。もうもう。

その後、草むらをかきわけて車で進んだ先に、これまた突然開けた場所が。石碑のようなものが立っている。「星名新田跡」と大きな字で書かれているようだ。

車を下車。これは昭和40年代に集落から人が転居してしばらくしてから、集落の記憶を残そうと建てられたものだという。ここ2、3年はだれも来ていなかった様子で、石碑にも苔が生えてしまっているようだった。丁寧に掃除をはじめる関口さん。石碑の前で記念撮影。立ち入り禁止エリアを脱出して、車で市街地まで戻っていく。

民俗泊物館に戻る車の中、おみこしを見た。連なっている子どもたちと大人たち。ああ、今日もお祭りなんだ。

日常はいつまでも続いていく。お祭り騒ぎはあっという間に過ぎ去っていく。それでも確かに日々は続いていて、市井の人々の小さな歴史が積み重なっていく。私たちはそれを、ただ垣間見ただけ、カメラのレ

美智江さんの家が建っていた場所
Where Michie's former home used to be

家があった場所の池に住んでいるトノサマガエル
Frog in the pond near where her home used to be

星名新田が廃村になった時に建てられた石碑
The stone monument was constructed when Hoshina Shinden became a ghost town

民泊レポート③　昭和町　樋口守雄邸

研究員の姓と同じ「長津牛乳」のポスト
A milk box with the same last name as researcher Nagatsu

ンズ越しに。こうして東京に戻ってパソコンを叩いて回顧するだけ。しかし、記憶は留めることができる。なにかのモノに共通の記憶を重ね合わせることができる。ちゃんこ鍋に、「星名新田跡」の石碑に、「ねころんだ」にある冷蔵庫（の役割を果たしていない冷蔵庫）に。こうやって新旧の記憶を重ね合わせることで、それは外から単に持ち込まれて去っていくものとは異なるものになる。そうして、この町に残っていく痕跡になっていくのだなあと考える。

　「ねころんだ」の前には、私と同じ名前の牛乳のポストがあった。出身は札幌だが、ルーツは富山県。もしかしたら遠い親戚かもしれない。

HOMESTAY REPORT 01 : AUSGUST 1ST-2ND, TAMUGI
KAZUHISA FUKUZAKI HOUSE

Reported by Kiyomi Ohta

It was truly a jam-packed two days.

I was born and raised in Nagoya. My parents are from Nagoya. It takes a mere 20 minutes by bike to visit my parents' house. Still, even though I am from the big city, I have always been fascinated by country life. Whenever I watched the T.V. show "Let's Stay in the Countryside" I thought how wonderful it would be to do that myself someday. So I didn't hesitate when I saw the open call for Homestay Museum researchers. As a researcher, I approached the experience with specific goals in mind. I wanted to learn about the everyday lives of the people and the culture that has so ensconced itself in the region, and how it is fairing in modern times.

The house I stayed at was the home of the leader of the Rokka District Promotion Association. The father of the family, with his kind features, is a lover of drink, talk and his dog. His wife, whom he met in junior high school, is skilled with the housework and watches over the home with her gentle eyes. The 84 years old grandfather still drives his truck out to the rice fields with the help of his wife, who is 90 years old. The final addition to the family is their 6 years old Labrador Retriever. They pulled out all the stops to create a comfortable atmosphere, making me feel like I had returned to my countryside hometown (which is really weird, considering my actual hometown is Nagoya.) It was like I had jumped into that Ghibli film, "Only Yesterday." I nearly forgot I was there to do research, I was enjoying myself so much!

THE RICHNESS OF LIVING, STARTING WITH FOOD

Dinner was fantastic. What a spread!

It consisted of vegetables harvested from the garden and the surrounding mountains. Most of the ingredients were obtained from somewhere nearby. The water also came from a nearby spring.

The rice came from the family's fields. They had everything they could need. The vegetables tasted delicious. We had food that is usually reserved for big festivals; whale soup, ego seaweed, spaghetti squash, bottle gourd, Japanese flowering fern, and boiled *boudara* (a type of dried cod). Of course, these are all things I could never get hold of in Nagoya. This is the slow life. I could tell Grandpa Fukuzaki treated his plants with great care. He always looks so happy when showing off what he has harvested. He takes a lot of pride in what he does.

"I was brought up by a strict father," he explains. "We've been planting sweet potatoes in that field for a good 20 years now. The field is the reason the potatoes taste so good." The potatoes harvested are delivered to the neighbor. Hundreds of potatoes just given away!

"At the moment, the Morocco beans (a type of string bean) can be eaten shell and all. But in a little while they will ripen to the point that you can only eat the beans inside."

With this comment, Grandpa Fukuzaki stood up abruptly, only to come back ten minutes later wielding a flashlight, a bag full of marble patterned beans in one hand and a bag full of dark crimson beans in the other.

"These are Morocco beans, and these are adzuki beans."

After dinner, Ma Fukuzaki and Grandpa Fukuzaki made some *dangos* wrapped in bamboo leaves, about 600 of them!

"Are you going to sell those?" I asked.

"Of course not, we are going to pass them out to the neighbors."

Wow, to give away so many *dangos*... I can't even imagine it. I guess that is just the type of person Grandpa Fukuzaki is. Or maybe that's just the way things are done in these parts. Or maybe both.

Whatever the reason, Grandpa Fukuzaki has three stockers...

Later I learned that the area has a long tradition of making preserves. They have something called "*anbou*." They mix rice flower with water and make a kind of dumpling with seasonal vegetables and beans. I suppose this is one of the many pieces of wisdom needed to survive in this area, famous for its deep snowy winters. They showed me how to peel off the bamboo leaves from the *dango*. The adzuki inside was also grown by Grandpa Fukuzaki, and it was amazing.

I stayed up late talking with Pa and Grandpa Fukuzaki, as we enjoyed our alcohol (though Grandpa Fukuzaki was a bit more of a reserved drinker than Pa Fukuzaki). It felt quite luxurious to partake of such delicious Niigata sake, mixed with the crisp local spring water.

But Grandpa Fukuzaki wasn't finished for the day. After Grandma Fukuzaki poured some boiling water into a container filled with the Japanese royal fern Grandpa had picked earlier, he added baking soda to the ferns, taking great care, because the amount of baking soda can make or break the flavor. This was all done to lessen the acidity of the ferns, and the end product was entirely dependent on how much and in what way Grandpa Fukuzaki added the baking soda. It was very apparent that Grandma Fukuzaki truly respected her husband's skill in this process.

LIFE IN THE SNOW COUNTRY CAN STAND WITH DISASTERS

Over dinner, prompted by the richness of the atmosphere, we began discussing the Chuetsu Earthquake that happened back in 2004. The Fukuzaki house was especially damaged, as it had been built on the fault line. It was considered totally destroyed and they said at the time there was a terrible slant to the house. However, it was still standing. This was thanks to the house's central pillar.

Since the snow in this area is particularly wet, the people here build their houses with a thicker than usual central pillar to help the house bear the weight of the heavy snow. This is what kept the Fukuzaki house standing during the earthquake and allowed it to be rebuilt afterwards.

They also talked about the evacuation. The day after the earthquake, everyone got to work. All the food could be obtained from the fields. The water was also no problem, thanks to the springs. They had always used propane gas and produced their own electricity, so the earthquake didn't cut them off from gas or electricity either. There were always a few construction vehicles in the village, so they were able to immediately get started on repairing the road. In fact, by the time the government got around to sending support, the villagers had already managed to repair the damage themselves.

"They brought food provisions, but we had to say, 'No thanks, we have our own.'"

"A team of doctors came but they said all the elderly people seemed to be eating healthily, so there was nothing to worry about."

How rugged these people are! When I think about the same thing happening in Nagoya, we wouldn't even have water. This made me realize the power of having clean water at hand. The way the people in the area all share their own food and vegetables is a great example of the feeling of neighborly love that pervades the area. Everyone is connected to everyone else.

But still, even in small communities, disasters can sometimes bring out the worst in people.

However, there is something to be said about seeing the worst of a stranger, versus seeing the worst of someone you know, someone you've always been connected to, someone who is your neighbor. I think this connection changes the way we interpret the situation.

Even in the worst of times, the wisdom and richness of the snow country pulls through.

"RICHNESS OF LIFE, GENTLENESS AS STRENGTH, RUGGEDNESS"

At first I thought I would be able to submit these things to the Homestay Museum, but I soon realized it was impossible. This life, these people, their history and the surrounding nature; for me these are not objects to be put in a museum, they ARE the museum.

I've always thought I have a lot I would like to learn from the older generation. Both my grandparents have already passed away, so I have to make the extra effort to connect with this wiser generation. In regions like this, where bonds are strong, wisdom, like that of Grandpa Fukuzaki and his baking soda, gets passed on naturally.

We worked our way back down from around the top of the mountain, where I was shown the spring near the rice fields. Whenever I think of how I would love this region to stay as it is, Pa Fukuzaki's words come to mind. When asked if he would like the younger generation to return to the area, he replied, "This is a very difficult place to grow rice. Even now I have to do farm work on top of a full time job. So how could I ask young people to come back and live here. City life is very convenient, you know."

These are words only someone from the region could produce. I don't really know what will or should come of this area, but I truly feel like my two days here, experiencing this lifestyle, making acquaintances, was really important and so impressive that it had an impact on even such a vain person as myself.

"Come back any time!" were words that made my heart skip. Of course I will!

SUMMARY CONTINUED

I asked the Fukuzakis if anything had changed over the years in what, to me, looked like a pristine lifestyle. After thinking for a bit, Grandpa Fukuzaki replied, "There are more bears and more boars."

In the past few years it seems that bears, boars and raccoon dogs (especially civets) have been increasing in the area. This is a problem for most mountain villages.

"It is because the mountains are being destroyed."

"Without a place to live, they all migrate here from over the pass."

"Hopefully, we'll find a balance that will allow us to live together."

In the past few years I've been rethinking what it means to live fully, but this trip really brought the quandary to the front line. Richness doesn't necessarily mean having the latest devices. Many people have the capitalist view in this world, you must make lots of stuff, buy it and sell it.

These people are destroying the mountains. The animals living in these mountains will seek refuge wherever they can, regardless of whether the area is already inhabited or not. There is no expectation for the younger generation living in the convenient big cities to come back to this region. In ten years, would the area become a real paradise for the refugee animals? Or could we finally find a way for all of us to live together?

HOMESTAY REPORT 02 : AUGUST 15TH-16TH, KOARATO
SHIGEZO IGARASHI HOUSE
Reported by Kazue Nakata

"You'll know the house immediately. It's the one with all the red loin cloths in front of it."
"What?!"

It was on August 15th, the middle of the Bon Festival, when we, following Fukasawa-san's simple explanation, found our way to Koarato Village near Matsudai Nohbutai. Just as Fukasawa-san had described it, we found the Igarashi house, where we were to stay, by spotting the statues clad in red loin cloths.

Afterwards we enjoyed the beautiful view from the outside bath of the nearby Unkai hot springs, and some delicious local dishes prepared by Emiko-san.

We spent our time relaxing and complimenting the food and atmosphere when, around 8 o'clock, Shigezo-san suddenly stood up.

"Put on your *yukatas*! We must dance the Bon odori. Time to go drink some beer!"

'FESTIVAL' IN THE MOST BASIC SENSE OF THE WORD 'OBON' IN KORATO

Yes, that day was the day that everyone in Koarato Village gathered for the Bon Festival dance. We all met on top the hill, about two minutes from the Igarashi house. There were about 50 participants in all. It was a festival for the people, by the people.

The song playing was a traditional Matsudai song. They didn't have a live singer as they did in olden days, so instead they used a recording of the song played on loop (which was made more enjoyable by the old men chitchatting in the recording's background). Everyone got in a circle and danced with slow and gentle movements.

All of the stalls and shops were run by villagers as well. This family prepared a chicken *shish kabab* dish called "*yakitori*." I was quite surprised to learn that all the *yakitori*, beer and other alcohol was completely free.

Everything had been prepared simply for the natural need to occasionally gather, eat, drink and dance. We felt really privileged and grateful to be part of such an important event. We were also lucky that everyone was so interested in us and eager to talk, as we were a rare sight in the village.

As a side note, we were absolutely terrible at dancing the Bon odori. The moves may be simple, and there may only be one song, but that means nothing when you've got no rhythm. Nonetheless, our awkwardness on the dance floor only prompted supportive words, kindly confirming the difficulty of the steps, or occasionally suggesting that we copy such and such an expert. Oh, I wish I had been born a dancer. Still, lackadaisically dancing around in circles, while singing along with the Matsudai music felt quite nice.

SUDDENLY, A LOTTERY

Just as we were getting the hang of things, the dance finished. Responding to our pleas for more dancing, a nearby elderly gentlemen told us, "One hour is enough. The best time to stop dancing, is when you feel like you could dance just a little more." Wise words.

Thus began the festival lottery. We were each given numbers while we were dancing.

The person in charge started calling out the numbers. "Number 25, congratulations! Number 18, congratulations!" Researcher Kurobe was happy to win a prize.

Just as I was wondering about my number 35... I won a tube of *wasabi*!

Wasabi, of all things! When I first got the wrapped prize, I gave it a little shake to see if I could guess what was inside. Imagine how hard I laughed when, expecting maybe jewelry, I unwrapped the package to find a tube of *wasabi*. In fact, all the prizes for the lottery were everyday household items.

In the Koarato lottery, there are no losers. It is designed so that everyone gets a prize. At first glance the wrapping looks like the kind you might find at an ordinary shopping mall, but a closer inspection reveals just how fancy it is.

Participating in Koarato's celebrations allowed us to reevaluate what is needed to have a festival.

A single song on loop, a single type of *yakitori*, hand-held fireworks, and a lottery you can't lose; this is all you need to have an enjoyable festival. Because of just how impressed we were by this event, we would like to submit Koarato's "Everyone is a winner" lottery to the Homestay Museum.

DRINKS WITH A SIDE DISH OF ART MANAGEMENT ADVICE BY IGARASHI-SAN

Even when the festival is over, Koarato is not.

After changing out of our *yukata*s, we once again gathered around the dining table at the Igarashi house. We sipped alcohol while listening to stories of the art festival, and tales of the Igarashis everyday lives, including how they met.

We drank. We drank a lot.

The Igarashis used to sell *tofu*. They made great amounts of *abura age*, a type of deep-fried *tofu*, for weddings and funerals. Their *abura age* sushi, or *inari sushi*, is amazing.

Out of all the stories we heard, those of Shigeyoshi-san's time volunteering at the art festival were particularly interesting. Shigeyoshi-san would be a prime example for any professional art manager. He really wanted to connect the artists, locals and administration together, and make the festival their own. Actually, I first met Researcher Kurobe when studying art management at collage. Also, we both first joined the Echigo-Tsumari Art Triennale at the same time 12 years ago. While we have traveled down different roads since graduation, Shigeyoshi-san's words brought back many memories from our school days; memories of the hard work that goes on behind the scenes of art and art festivals.

We were so impressed with what Shigeyoshi-san had to say that we would like to submit as our second piece "A collection of sayings about art management" by Shigeyoshi Igarashi.

CARS AND EXERCISE, MAKING THE MORNING ROUNDS, AND PRESSED FLOWERS!

We only stayed a single night, but the stories we have of the Koarato Village and the Igarashi house are too many to record. Since this is already too long as it is, I will summarize what is left.

Some radio aerobics the following morning. Much easier to follow than the Bon dance.

Surprisingly, they used a car radio for the aerobics. Pictured is the second car, after the battery of the first car gave out.

After aerobics, a walk through the village with everyone.
The walk ended with this year's artwork for Echigo-Tsumari Art Triennale, an installation at the local shrine by artist Maki Kijima.
The birds were made by locals during a workshop. Each piece was of amazingly high quality.
This is Shigeyoshi-san's bird. He has a great feel for color and shape.
You can definitely see how both the artists and the collaborating locals have improved themselves with each passing Art Triennale.

Afterwards, we got to pick some vegetables from the Igarashi house garden.
We also went up to the attic to see some leaves drying to make Houttuynia tea.
Emiko-san also taught us how to press flowers. She makes artworks from pressed flowers.
It was such a fantastic stay, we feel like we could never properly express our thanks in words.

For those visiting the Echigo-Tsumari Art Triennale, Koarato is a must see.
The Matsudai area, where the Igarashi house is located, is now also taking homestay inquiries for their year-long program "Oyakko Village."
Since first attending the Triennale in 2003, I have come to this area three more times, in 2006, 2012 and 2015. However, this was the first time I felt like I really got to interact with the local people and get a glimpse of their lives. Homestay is truly a wonderful experience.

I reckon even today the statues outside the Igarashi house are sporting their red loin cloths.

HOMESTAY REPORT 03 : AUGUST 25TH-26TH, SHOWA-CHO, MORIO HIGUCHI HOUSE
Reported by Yuichiro Nagatsu

A 4 o'clock start. I was first guided to a hot spring. Afterwards, I arrived at Morio Higuchi's home a little past 5:30. Higuchi-san has been living by himself since his wife passed away 10 years ago.

However, when he picked me up, he was accompanied by the neighboring couple, the Sekiguchis, and their nephew. We greeted each other and began the evening's festivities. It was a packed schedule.

First up was *chanko nabe*, a type of Japanese stew most famously used in sumo stables. This was proper *chanko nabe* made from chicken bones, just like the kind Higuchi-san occasionally made for sumo wrestlers training in Tokyo. That's right, Higuchi-san used to work with sumo wrestlers, as a kimono wholesaler. A sumo wrestler list could be found hanging in the corner of his room. Higuchi-san's name was listed as the Kanjinmoto (a special sumo word that means "sponsor.") This got me quite excited, as I was a big sumo fan when I was younger.

We finished the *chanko nabe* in no time, and another was prepared. About halfway through the second pot, it was time for us to move to the next event. We left the house and headed to the Tokamachi shopping center.

Traditional folk music could be heard throughout the shopping center, as it was the day of Tokamachi's festival called "Oh-matsuri." Without really knowing what was going on, I borrowed a *yukata* and headed into the night lights of the town.

Blocked off to traffic, the streets were crowded with people. I spotted someone carrying a sign that read "City Center Revitalization." Thinking myself the only outsider, I felt a little uneasy at first. I quickly got over it, however, when I realized that only half of the people on the streets were locals, while the other half were visiting for the Echigo-Tsumari Art Triennale or were working for the construction of a new city office. Quite a few people weren't from the area. This made me feel a little more relaxed. Every now and then a group of people carrying what looked like a large lantern would pass by.

At one point, someone began an unprompted lecture on how to dance. The two types of dance were the Tokamachi Ko'uta and the Miyuki Jinku. They are rather simple dances in nature, but it takes a lot of effort to get them down pat.

Soon, after the start of the dance was announced, the music began to play from the speakers. Following some unknown signal, the people in the streets began to dance. Slowly, but surely, they started making their way forward. Whenever we crossed an intersection, we could see people doing the same dance from all directions! This was when I first really understood the actual scope of this festival, and I was quite surprised. We then made a left and headed straight on. A double lane of traffic was created with the regular dancers on one side and the dancing teams from the local public schools, dancing schools, banks, business and politicians pouring past us on the other. You could tell they do this every year. Their moves were really in sync. (The City Center Revitalization team had also gotten pretty good by this time.) We danced the Tokamachi Ko'uta twice and the Miyuki Jinku once before leaving just as the rain was starting to fall. The dance was closed with a round of applause.

After having a brief meeting with the Tokamachi City Center Revitalization team, I changed out of my *yukata* and headed back to the Higuchi house to finish off the *chanko*

nabe. Sekiguchi-san's nephew and husband were already asleep. Once again the delicious sake "Matsunoi" made an appearance.

Even though we were already full, we began eating again. Higuchi-san is quite a talker. We talked about work, sumo, and Tokamachi. It was a great time spent letting the amazing sake slowly relax us. Before we knew it, the *chanko nabe* was empty again. It was time to call it a night.

At 11:30, I slipped into my futon on the second floor and fell asleep before my head hit the pillow.

Up at 6:15. This is quite exceptional considering I am NOT a morning person. I quickly got myself dressed and made my way to the living room by 6:30. Breakfast was heaps of *sekihan* (rice with red beans) made with *kintoki* beans. Just seeing the color of the beans really gave me a great feeling. The *mochi* (glutinous) rice was glistening. It looked so delicious. The amount was also astounding. The rice looked like it would taste good with anything.

Originally, we were supposed to harvest some vegetables and eat them for breakfast, but sadly we couldn't due to the strong winds and bad weather the previous day. Nonetheless, the *sekihan* was amazing. Many thanks to Sekiguchi-san! I even found myself having seconds, despite it being so early in the morning. This is where I bid farewell to Higuchi-san. I tried to do the dishes but he told me, "Don't worry about it. I have a system." Such a gentleman! (He had said the same thing the previous night when I tried to do the dishes from dinner.) We took a picture together and then I said goodbye. I hope I will be lucky enough to meet him again someday. We said farewell and made our way to the next place.

The next stop was "Nekoronda," run by Michie Sekiguchi. This is a space for those who have trouble getting out of their house and interacting with people. Those who suffer from this kind of social anxiety are called "*hikikomori*" in Japan. Nekoronda helps *hikikomori* and their families by creating a space where they can relax and be constructive by making things. The place itself was quite spacious. So much so that I wondered if it used to be an office. There was lots of room to move around. They redid the flooring themselves. Sekiguchi-san excitedly informed me that soon they would have an exhibition at the Tokamachi Industry and Craft Center "Ikote".

Our next destination was Sekiguchi-san's hometown. She had lived for a long time in a region of Tokamachi called Hoshina Shinden. This is near the "House of Light" by James Turrell which is part of the Echigo-Tsumari Art Field. As we were driving, I saw a sign that read "road restricted to field workers and property owners." The road was chained off. However, Sekiguchi-san simply got out of the car and unlocked the chain. The road was so narrow, you could hear the surrounding plants scratching the car as we drove by. Had we opened the windows, we would most definitely have been attacked by the branches of the roadside trees and bushes. After losing sight of the village, two people working the rice fields came into view.

As we continued, the surrounding mountains opened up to reveal rows of rice terraces. It felt like we had stumbled onto some hidden land. The rice terraces sparkled, reflecting the blue sky. It was a truly amazing sight. After leaving the car, as we walked along, Sekiguchi-san pointed out where flood relief construction had been carried out for the rice fields.

HOMESTAY REPORT 03: MORIO HIGUCHI HOUSE

Next, she showed us the place where the house she grew up in once stood. All that is left now is the well they had used. Sekiguchi-san walked around the empty lot, pointing out where different rooms in the house had been, but all we could see was the vast grassy expanse.

In the nearby pond lived a family of frogs. Sekiguchi-san slowly made her way over to the old sealed-off well to open it and have a look. When she had finally pried the top off, something erupted from within the well. Without taking the time to check what it was, we all escaped as quickly as we could. After the fact, it occurred to me that earlier in the car, Sekiguchi-san had warned us that there was a wasp nest in the well. Despite knowing this, we hadn't even bothered to roll up our windows when we first left the car!

Furthermore, having herself warned us about the wasps, why would she be fiddling around with an old well in the first place! A stream of wasps flew straight for us as we made a mad dash for the car. We quickly rolled up the windows and drove off. Sekiguchi-san, what were you thinking?!

As we made our way through the bush, we suddenly came upon an opening and something that looked like a stone monument. On it was written "The remains of Hoshina Shinden." We got out of the car to have a better look. The monument had been constructed by someone who left the village in the late 60s. The thick covering of moss showed that no one had visited the monument in several years.

On the way back to the Homestay Museum, we saw a *mikoshi*, or traveling shrine, with a trail of adults and children behind it. Ah, the festivities continue.

Everyday life continues uninterrupted, but the uproar of the festival finishes before you know it.

Even so, the days continue, and those people on the street add another day to their past. We are just onlookers, catching a glimpse, through the lens of a camera, and returning to Tokyo to upload our findings. However, we do have memories; memories of *chanko nabe*, Hoshina Shinden monuments and useless refrigerators at Nekoronda. In this way we pile our new memories on top of our old ones. We do something more than if we were to simply plunder some artifact and return to the museum. We leave a more lasting mark on the area.

There was a milk box with the same last name as mine in front of Nekoronda. My family is from Sapporo but has ancestors from Toyama. Perhaps Nagatsu is a distant relative of the people in Echigo-Tsumari.

エッセイ
ESSAY

その時間（夕顔の転がり込んだ、）

谷 竜一
詩人・演劇作家・集団「歩行訓練」代表

　民俗泊物館の「はく」が泊まるっていう字なんです、と係の人物が解説してくれる。越後妻有民俗泊物館は、必ずしも美術作品を収蔵する場所ではない。一般の歴史資料館のように資料を収蔵する場所でもない。一般公募によって集められたみんぱく研究員が、越後妻有の特徴的な民家に1泊2日のホームステイをし、そこで発見した暮らしぶりの資料を借りたり、あるいは再現したものを収蔵しているのだ。

　収蔵品は多岐に渡る。このあたりではただ1軒になってしまった鯉の養殖池、冬季保存用の野菜の瓶詰、保育園に勤めていたお母さんの娘を描いた絵。研究員たちがそれぞれの視点で収蔵してきたのは、二重の意味で一般的な資料ではない。まずそれは、「隣の家はウチとちょっと違う」というような、ごく素朴なその家庭の独特の生活スタイルや出来事の刻印がみえるものである。「人がたくさん来たから使ってないキャンバスを裏返しにしてお盆にしたもの」なんていうのが展示されていて、ちょっと笑ってしまう。

　そしてその生活は、多かれ少なかれこの地域の風土や歴史を反映したものである。そのキャンバスがあることそれ自体が、このお母さんがこの土地で暮らしてきたからこそ、そこにあるように。ここでこの人は、絵画を描いていた。そして今は、使われていないキャンバスがあり、絵画とはまた別の理由のために、迎えるべき人がいる。

　象徴的な展示品があった。駒返の今朝松さんが、信濃川発電所を定年後に始めたという藁仕事だ。かつて藁工芸と農家の暮らしは一体のものであったが、彼が始めたときには既に、生活と結びついたものではなかった。定年後に、物質的な豊かさだけではない暮らしを見直そうと始めたという。現在は観光の体験道具やお土産品、しめ縄などを作っており、彼の工芸の歴史はもう20年ともなる。

　外から人がまちへ訪れ、まちを見るとき、その歴史はさも一本の途切れることのない線的なもののように見えてしまう。しかし実際にはしばしば断絶があり、ときにはその断絶を繋ぎなおそうという尽力や、また逆に何の気なしに始めてしまった気まぐれがある。現在の暮らしを収蔵するこの泊物館の資料たちは、鑑賞者たちに距離的にも時間的にも身近な、それでいて確実に隔たっているそれぞれの暮らしを伝えてくれる。

　それでも泊物館全体がユーモラスな雰囲気を保っているのは、こうして隔たったわたしたちの暮らしが、今もそれぞれにそこにあるということへの信頼感からきている。あらためられた「共に生きている」ということの確信が、研究員たちの民泊のまなざしには宿っており、その視線こそが彼らの研究員としての最大の成果だ。

　ある家庭にあった夕顔が展示されている。食べる以外にも乾かすとひょうたんになるのだとお父さんが説明してくれたそうだ。だが、お母さんによるとお父さんは自分でやったことはないという。しかしお母さんもやったことはないそうで、ではどうしてこの夕顔を乾かす方法をこの人たちは知っているのだろう。この夕顔はどうなっていくのだろう。案外と歴史はこうして現在に転がり込んでいる。その現在の姿を、わたしはこの奇妙なあたりまえの博物の館で見ていた。わたしはどうしてこれが「夕顔」であると知っているのだろう。そのしっとりとした肌を割ってみた歴史が、わたしにはない。

　ひと夏の展示期間を終え、越後妻有民俗泊物館も閉館する。展示物はそれぞれの生活に帰っていくのかもしれない。あるいは破棄されるのかもしれない。運がよければどこかで、また見ることができるのかもしれない。そのときにはわたしも、「かつてこの街には民泊っていうのがあってね」としたり顔で語るだろうか。あるいはまたしても未定の歴史に転がり込んでしまった夕顔を、どうしたもんかと苦笑するだろうか。そのときわたしたちが語る時間は、まだみずみずしさとユーモアを保っているだろうか。

システムとしての深澤孝史、あるいは深澤孝史というシステム

山口 祥平
第6回大地の芸術祭 越後妻有アートトリエンナーレ
十日町市街地プロジェクトディレクター

「越後妻有民俗泊物館」「とくいの銀行」など、深澤作品にはなにか施設めいた名称が少なくない。大袈裟な名称だけに冗談にも見えかねないが、深澤作品は現実の社会関係のなかで、多くの理解者を得ながらプロジェクトとして進行している。作品といっても、見た目にわかりやすい「モノ」になっているのではなく、作品が展開される場に複数の要素が散りばめられ、どこが作品なのかはよくわからない。観客は空間に遍在する断片と接触しながら、自身の経験を紡ぎあげていく。一様の理解では捉えられないところが深澤作品の特徴である。

2015年の大地の芸術祭では、深澤は「博物館」をテーマにプロジェクトを展開した。その名も「越後妻有民俗泊物館」(以下、泊物館)である。名称そのものは、深澤の文章を参照いただくとして、ここでは作品の特徴を見ていきたい。一般に博物館といえば、民俗学、文化人類学等の学術的知見に基づいて調査研究・収集保管・展示公開が実施されるが、泊物館では、アーティストがこれらの博物館の機能(調査研究、収集保存、展示公開)をアレンジしている。

博物館の諸機能に携わるのは、アーティストと「研究員」と称される専属スタッフである。研究員と言っても、専門家ではなく一般公募のボランティアスタッフであり、展示資料の選定基準となるのは、学術的観点ではなく「個人的関心」である。個人的関心から選び抜かれた資料たちは、通常の博物館とはいささか雰囲気を異にしつつ、学術資料とは違う越後妻有の姿を切り取ってみせる。たとえば、小荒戸集落の紹介における油揚げづくり道具を押し花作品づくりに転用するエピソードからは、豪雪地ゆえに冬籠り期間が長いこと、物を大事にする慎ましい生活習慣、経済活動から解放される里山生活のゆとりなどが、現地に赴いた研究員個人の温かみを伴って解説される。

泊物館のユニークさはこの解説にも色濃く現れている。観客は泊物館に足を踏み入れると、館内に配置された多数の「解説メディア」に取り囲まれる。

受付で手渡される泊物館のカタログ、人感センサーで始まる音声案内、研究員による詳細な民泊体験解説、時には館長と称するアーティストによるプロジェクトの説明など、観客は多様な語り部に包囲される。もはや館内では展示物を見ている時間より、解説を聞いたり、カタログの文章を読む時間のほうが長い。滞在時間もツアーの関係等で急ぎ足で回っている人は10分くらいだが、長い人は2時間半近く館内にいたという。

一見、過剰とも見えるシステムだが、観客の持ち時間に合わせて、提供される情報量も調整される。多様な観客に対して、適度で多彩な経験を可能としている。

このように泊物館は、アーティストが博物館の諸機能をアレンジし、空間に巧みに「解説メディア」を配置させることで、都市からの来訪者を越後妻有の生活文化に引き合わせる。多くの芸術祭の来訪者は、里山で作品巡りをし、その美しい風景や美味しい食事に触れる。しかし、その裏にある、越後妻有の日々の営みまでは知る由もない。過疎高齢化、豪雪との格闘の日々、あの美しい景色と食文化は、ここに長きにわたって住み継いできた人々によって保持されていることを。泊物館で出会うのは、一見ではわからない越後妻有の日常であり、さまざまな時代の奔流に巻き込まれつつも力強く生活してきた個人の時間であり、生である。

深澤作品に足を踏み入れて顕著に感じるのは、この個人の生に対するアーティストの関心であろう。今ここに、現に生を受けている個人、その存在に対する深い敬意と温かな眼差し、それはアーティストをプロジェクトに駆り立てる原動力ともなっている。「越後妻有民俗泊物館」という里山の生活に遭遇するシステムは、この動力を抜きにしては機能しないだろう。深澤孝史という個人の関心こそが泊物館というシステムを駆動させている。深澤孝史のシステムは、館内に足を踏み入れる人々を、ここではないどこかへ、他者の生へと導き、新たな旅路を開いてくれるのだ。

息継ぎの共有

青木淳
建築家

　まわりから「こんな変わった家が設計できるなんて、どうやって施主を騙したの？」と、ときどき聞かれることがあるが、何も「騙した」わけではなく、「うちはごく普通の、これと言って、特徴のない生活をしていまして」と言いつつ住宅の設計を頼みに来る方と、やりとりを始めて、家ができあがってみると、結果的にかなり変わった家になっているのにすぎない。

　それが証拠に、住まい手は、できあがった自分の家を、特段、変わった家だとは感じていないことがほとんどだ。

　本人が普通だと思っていても、付き合ってみると、人それぞれでずいぶんと違う。もちろん、設計するぼくとも、好みも、生活観も、違う。それで、住宅を設計している間、ぼく自身の好みや生活観を封印して、相手に仮託する。すると、ぼくが自分で無意識に縛っている約束事から解放される。身体化してしまっている約束事に気づき、それを相対化できる。

　こういうことを続けていると、つくづく、人それぞれでバラバラだと思う。バラバラな人がバラバラのまま集まっているのが、本来は、人の集まりだろうと感じられてくる。

　その一方で、ぼくたちは、人が集まると自然に均質化がはじまることを知っている。枠組みが生まれ、それが人を縛りはじめることを知っている。

　住宅を設計するということは、ぼくにとって、自分もきっとそのなかに入ってしまっているその枠組みを揺さぶることなのである。

　深澤孝史さんがやられていることを見ていると、ふと、そんな自分のことと重ね合わせて思えてしまう。

　山口情報芸術センターと札幌国際芸術祭2014での「とくいの銀行」を見た。「とくいの銀行」では、町の人それぞれが、自分が得意にしていることを「預ける」。その「とくい」を組みあわせ、札幌の場合ならば、札幌開拓のもうひとつの歴史を紡いで見せる。

　プロジェクトは、ふたつの方向に分裂している。ひとつ目の方向は、実は人それぞれで皆、違う、そういう人のとりあえずの違いを入り口として、その人のさらなる固有性に出会っていく旅のようなもの。それから、その固有性があるからこそ生まれる集団的状態を、その土地の固有性のなかで、もう一度、仕込み、熟成させてみる醸造のようなもの。ミクロへ分け入る方向と、マクロに広がる方向に、分裂している。

　人も土地も、皆、基本的には同じに見える、そんな均質性のなかから、それぞれの固有性を浮かびあがらせていく。そうして「裸」にされた土地という土壌と、「裸」にされた個人という種子とが掬いとられる。

　土壌に種子を蒔く。種子が芽生え、茎が絡まり、葉が茂って、野原になる。ただその野原は、なぜか、見慣れた野原ではなくなっている。その土地の土壌に、そこに生きる種子を蒔いたのに、別物になっている。

　そこで、今、目の前に見えていることが絶対ではない、他の可能性もありえる、ということに気づく。と同時に、ふわっと体が浮くような気持ちになる。その瞬間、ぼくたちは、知らぬ間に身体化してしまった約束事から解きほぐされる。

今、それぞれの人の固有性、それぞれの土地の固有性、と言った。でも、それらは本当に固有なのか。それらさえ、身体化した約束事なのではないか。「越後妻有民俗泊物館」を見て、そのことを感じた。戦後、収入を得るための手段として、鯉の養殖業を選択したのは必然だったのだろうか。40年前に、北海道名物のジンギスカン鍋が流行したのも、それが廃れたのも、その鍋が畑で使う重石になったのも必然なのだろうか。父親が獲得したゲートボール大会の金メダルが鈴なりに吊るされる家になったのも必然なのだろうか。

　近づいてみれば、多くのことが、偶然の連鎖でできているように、見えてくる。人や土地の、確たる固有性と見えたものが、振り返ってみれば、どうも、あやういい綱渡りの、かろうじての平衡状態であるように思えてくる。無数の粒子が離合集散して、たまたま形づくられた星座のように見えてくる。

　しかしおそらく、それは完全な偶然ではない。どこかに、何か筋があるに違いない。もちろん、それは一言で言い切れるような筋ではないだろう。話し出すと、きっと長い話になるに違いない。しかも途中で、話は混線し、堂々巡りを始めるかもしれない。

　ここにも、分裂したふたつの方向がある。一方に、偶然の彼方に飛び散っていくバラバラさを追っていく方向がある。またその一方で、それらを繋ぎ止めようとする「読み取り」の方向がある。

　組み立てつつ、崩し、また組み立てる。そうして、浮かび上がってくるのは、現実と等価な、ただし彼を通して一度リセットされた、バラバラの偶然と歯切れの悪い筋書きとが織り成す、もうひとつの現実という綾織である。

　それが、深澤さんにとっての「つくる」ということの意味のように見える。その「作品」は、形を持たないし、一見そう見えるようには、必ずしもコミュニティにコミットしない。

　それは一義的には、他人と出会うことで、自身の身体化した約束事の外に、一歩でも出てみようとする、彼個人の試みなのだろう。もしそこに共有ということがあれば、その一呼吸でも新鮮な空気を吸ってみたいと、皆が潜在的に感じている息継ぎの経験なのではないだろうか。

深澤孝史の美術作法

北川フラム
大地の芸術祭 越後妻有アートトリエンナーレ 総合ディレクター

　アーティストは不思議な種類の人だな、と思ってしまう。定年後、民俗学の研究をし藁仕事を始めた人の家に泊まり話を聞きその生活を彷彿させる展示をする、という具合に。その家の床の間には、戦争で身体を壊し民俗学にのめりこんだお兄さんが発掘した縄文土器が飾られていて、その写真を撮って飾るのだ。その藁葺屋根に住む80歳の老人はアスパラガス農家であり、そのユニークな収穫方法も写真に撮られている。

　宮本常一さんのような民俗学者なら聞き書きして帰り、記録するところが、アーティストならこうなってしまう。まさに美術とは、expose（さらけ出す）行為なのだ。

　豪雪の山間地である越後妻有では、江戸時代から蛇行する川の流れをショートカットして、もとの川の低地を水田に替える瀬替えという水田作りの方法がある。さらに冬の出稼ぎを止めようと瀬替えの田んぼにまた水を入れ、養鯉池をつくったという話を別の場所でアーティストは聞いてくる。そこには、山村の農業の厳しさ、出稼ぎの苛酷、養鯉の一稼千金、そして1万匹のうちの1匹以外の残酷な運命について伝えようとするのもアーティストなのだ。また、今まで見たことのないほどのゲートボールのメダルや、猫の出入りのため口切られている障子や、オバケのような夕顔や、40年前流行の北海道旅行のあと重石として重宝されてきたジンギスカン鍋を見つけてくる。これは民俗学者の眼差しではない。ここでアーティストは、あくまで人間の些事にこだわる人種なのだ。彼らがそこに見るのは、神や人間や、勿論、社会通念からの視点ではではない。些事にこだわるというのは、個々の生命やモノからの視点を大切にするということだ。

　こうやって見てくると、アーティストは民俗学者とはとても違った人間で、ある意味では図々しい。人の懐に入っていってしまう人たちなのだ。

　私は深澤孝史について書こうとして、アーティスト一般について書いているようだ。しかし、こんなアーティストは少なくなってしまった。アーティスツ・アーティスト。

　「民俗泊物館のしくみ」については別ページに紹介されているので反復は避けるが、ここでアーティストは膨大な予備調査をすでにしていて、みんぱく研究員希望者にそのガイダンスをし、ツアーガイドをし、泊物館のキュレーターをする。12軒の家と30人の研究員が参加したことになっている。大変な数だ。他にも展示物の模型製作など、もろもろに動くのだが、これはおそろしく全人的な活動なのである。実際、芸術祭の会期中、深澤さんはかなり会場に居たように思う。このあたりの経緯―目的―感想は深澤さんの「普通の人の博物館」にわかりやすく書かれている。

　初めて深澤さんを知ったのは3.11の震災後の2011年夏。小沢剛さんがやっていたまつだい農舞台の「かまぼこアートセンター」のアーティストとして、東北や都市の子どもたちを招いて行った林間学校に深澤さんが助っ人として参加した時だった。

豪雨のため子どもたちが宿泊先の三省ハウスに閉じ込められた丸一日、深澤さんはいろいろな種類の遊びやゲームを考案して、子どもたちを飽きさせず、かつ楽しいチームワークにもっていったと後にスタッフから聞いた。その時、僕の中で「フ・カ・サ・ワ」という名は遊びの天才、アーティスト・アーティストとして刻印され、尊敬する人間として、登場したのだった。

　こういう人が、角質化、平均化し、マニュアルがなければ何もやれない時代、最も大切な人なのである。そんな役割を担うことこそがアーティストの栄光であり、そういうアーティストが地域に入っていってこそ、21世紀の美術、人間と自然、人間と文明との関係性の美術が成立するのではないかと思えるからなのだ。

　民俗泊物館はそれ自体として越後妻有という豪雪の中山間地に分け入っていく作業であり、その地域の長い間の自然との関係を明らかにする作業であり、その地域の人々と来客をつなぐ作業である。これこそ僕らが求めていたアート活動のような気がしてくる。彼が今後どのような活動をしていくか注目しているのだ。次代のアーティストの誕生を、私たちは間近にみているのではないか。

DAYS BEFORE (THE BOTTLE GOURD ROLLED IN,)

Ryuichi Tani
Poet, Playwright, Director of the Group "Hokoukunren"

This Museum is called a "homestay" museum for a special reason, but I will let the director go into that himself. The Homestay Museum is not simply a place to store artwork. Nor is it an ordinary collection of historical pieces. The Homestay Museum is a collection of objects discovered when our researchers stayed the night in various houses in the Echigo-Tsumari region. The items were then either borrowed or reproduced to be put on display at the Homestay Museum.

The collection covers a broad range of topics; the only carp hatchery remaining in a once thriving area, jars for winter preserves, and pictures by a former preschool worker of her daughter; just to name a few. The objects in the museum were chosen based on each researcher's individual perspective and have come to form what is, in many ways, an unusual collection. The collection accentuates the individualistic styles of these rustic homes and shows that even though two houses may be neighboring one another, they are their own unique entities.

Some of the displays will offer you a laugh, like the old canvas that was turned upside down and used as a tray because "so many people came to visit!" This lifestyle, more or less, reflects the culture and the history of the area. The very reason for that canvas's existence is because its owner had lived in the area. The canvas is here because its owner painted here. But now, apart from its artistic past, the canvas has a found new people to benefit.

There are symbolic pieces on display as well. The straw crafts of Kesamatsu-san from Komagaeri, who began working with straw after retiring from the Shinano River Hydroelectricity Power Plant. Farm life and straw work used to be deeply connected, but by the time Kesamatsu-san had begun exploring the craft, the two had lost their dependence on each other. After retiring, he began to feel that livelihood consisted of more than just material. At present, he makes ritualistic straw ropes, called *shimenawa*, as well as other crafts to sell travelers. He also holds workshops. He has already entered his twentieth year of craft career.

For outsiders visiting the city, its history must appear as a single uninterrupted line. However, in actuality, the history of the area has seen many rough times. Sometimes it has taken all the efforts of the local people to get through those bouts of trouble, and yet sometimes it seemed like everything just worked itself out with great ease. The displays at the museum are of modern day life, and are both in a spatial and temporal meaning "close to the viewer." Yet they each portray a distanced lifestyle.

What really maintains the humor of the Homestay Museum, however, is the trust that this lifestyle we have, which is so different from the one we see in the museum, will still be there upon our return. This reassurance in what it means to "live together" is the greatest accomplishment of our researchers. We can discover this meaning through the eyes of our researchers.

The Eguchi house has a bottle gourd on display at the museum. Eguchi-san told us that the bottle gourd is not just for eating, but can also be dried out and used for other purposes. However, his wife informed us that he had never actually tried to dry out the gourd before. Neither has she herself ever given it a try. So we begin to wonder how it is that they know how to dry out the bottle gourds. What is to become of these bottle gourds? Oddly enough, this is how history finds its way to us in the present. It is through this odd museum of common sense that we are able to see history's present shape. I wonder how it is that they even know the plant is called a "bottle gourd." I certainly have no experience with the bottle gourd myself.

The Homestay Museum finished its first summer exhibition and closed its doors. The objects may find their way back home, or they may find themselves in the dump. If their luck is good, they will find their way back to a display somewhere. If so, I hope I will be able to confidently say, "Once upon a time, there was a Homestay Museum in Echigo-Tsumari". Or, if it is the bottle gourd and its undetermined history, I will say with a grin, "I have no idea what it is?" I hope when that happens, that our conversations will still have the same freshness and humor they have today.

TAKAFUMI FUKASAWA AS A SYSTEM, OR THE SYSTEM KNOWN AS TAKAFUMI FUKASAWA

Shohei Yamaguchi

Director, Tokamachi City Center Project, Echigo-Tsumari Art Triennale 2015

Fukusawa's works, "Echigo-Tsumari Homesetay Museum" and "Tokuino Bank," quite often have names more fit for institutions. Such exaggerated names might appear as a bit of a joke. However, Fukasawa's works have been advancing while picking up many sympathizers among people who are concerned about present-day society. They are not "objects" which can be so easily seen with the eye. His works scatter various elements across an ever-developing area, making it unclear as to where the creation begins and ends. The viewer interacts with the space's omnipresent fragments, while interweaving it with their own personal experiences. The extreme difficulty in coming upon a uniform interpretation is a particular characteristic of Fukasawa's works.

For the Echigo-Tsumari Art Triennale 2015, Fukasawa realized a project based on the idea of "museum". The project was The Echigo-Tsumari Homestay Museum. As for the naming, I will let Fukasawa go into details about that himself, and instead I would like to focus on the particulars of this project. In general, the term "museum" brings to mind something researched, collected, maintained and set up for public display, and is based on some discipline of study, like cultural anthropology or ethnology. However, the Homestay Museum has the artist arranging the various functions of the museum (such as research, gathering and maintaining objects, and public displays). Those engaged with the various aspects of the museum are the artist and unique staff referred to as "researchers." These "researchers" are not professional specialists, but actually volunteers from the general public. The basis for selection is not academic, but of personal interest for each researcher. By displaying articles chosen for personal reasons, the Homestay Museum creates a slightly different atmosphere from ordinary museums and represents a picture of the Echigo-Tsumari region that differs from academic data.

For example, on display for the Koarato Village is a piece of equipment, once used to make deep-fried *tofu*, that has been refurbished to press flowers. This display illustrates, via the warmth of the individual who went there, the long period the villagers spend holed up inside their homes due to the heavy snowfall in the region, the way their humble lifestyle cares for the objects they own, and the general leeway that comes from a country life liberated from the finance-centered lifestyle of the cities.

The Homestay Museum's uniqueness is very apparent in this illustration. Upon stepping into the Museum, the viewer is taken in by the many "commentary medias" that are placed throughout the building. At the front desk, everyone is given a catalog of the Museum. Sensor activated voice recordings guide you as the researchers give details of their experiences. Sometimes one will even get explanations of the various projects from the artist himself, who is referred to as "director." In the Homestay Museum, you are always

enveloped by a myriad of storytellers. It is quite likely that you will spend more time listening to the narrations and reading the catalog than looking at the actual displays themselves. As for time, in a rushed tour you could see the place in about ten minutes, but those who like to move at their own pace have been known to take nearly two and a half hours. At first, this system may appear a bit excessive, but the information that is being provided has been adjusted to meet each guest's waiting time. A wide variety of experiences are available, to meet with the wide variety of guests.

In this way, by having the artist arrange the museum's functions, and by providing commentary media in a skillful way, the Homestay Museum is able to draw interest to the life of the Echigo-Tsumari people even from those who live in Tokyo. Many visiting for the art festival make the rounds to see art displayed in the village forests, and are exposed to the beautiful scenery and delicious food of the area. However, they have no reason to know of the daily goings-on of the Echigo-Tsumari people behind the scenes. They never learn of the aging population, the daily battle with the excessive snow, or the people who have spent many generations maintaining the beautiful scenery and delicious food culture. What you meet at the Homestay Museum, while not so easily understood in a single glance, is the daily life of these people. You meet those individuals gallantly fighting for their way of life as it gets caught up in the torrents of a variety of generations. This meeting is very real.

Something you markedly feel when you set foot inside a Fukusawa work is the artist's regard for the life of the individual. There is a deep respect and a warm regard for the individual living now and here, and this can be the force that drives the artist to create. This system that interacts with the country life known as the Echigo-Tsumari Homestay Museum cannot function without this drive. Takafumi Fukasawa's personal passion, in particular, is the driving force behind the Homestay Museum's system. This system guides those who enter the Museum to the life of some other, from some different place, and opens up for them a fresh, new road.

SHARED BREATH

Jun Aoki
Architect

I am often asked "How did you trick your client into allowing you to design such an unusual house?" but there is really no "trick" involved. We go about things in a perfectly normal way, that is to say, there is nothing particular about our methods. Even with this being said, after discussing designs with our clients, and once the house itself has been built, nothing more drastic than "fairly different," can be said of the finished product. As proof of this, for the most part, our clients do not feel anything odd about the home they have had built.

While the clients themselves may feel their setup is perfectly normal, as I get to know them, I find each person has a drastically different understanding of the word "normal." Of course, as a designer, my own likes and lifestyle differ from theirs as well. However, when I work with a client, I must seal away my own likes and preferences and place myself in the client's shoes. By doing this, I free myself from the various restraints that I had been subconsciously holding on to. Once aware of these internalized rules, I am better able to confront them.

By continuing this, I have realized that people are utterly and entirely different from each other. I also feel that, originally, when people come together, it is in this state of utter difference.

However, I am aware that once people come together, a natural process of homogenization occurs. Boundaries are built, and these boundaries restrain us.

Designing houses, for me, is about shaking these boundaries; boundaries that I too am restrained by.

When I see Takafumi Fukasawa at work, I tend to inadvertently superimpose myself over him.

At the Yamaguchi Center for Arts and Media and during the Sapporo International Art Festival 2014, I witnessed the Tokuino Bank("tokui" is Japanese for "special talent"). In the Tokuino Bank, each person in a town "deposits" one of their talents in the bank. These talents are combined and, in the case of Sapporo, are displayed after being woven together with a piece of Sapporo's history, like the process of the city's founding.

This project can be divided into two different philosophies. One part is like a trip where we use the fact that we are all different from each other as the jump-off point to discovering our own individuality. The other is like a brew that, prepared within the unique nature of the land, matures the collective state that is born from the individual characteristics we all have. One philosophy zeros in on the smallest discrete unit, while the other expands out to look at the whole.

People, and land, for the most part, all look the same, and from this homogeneity, individuality rises to the top, where we scoop out the "soil," land stripped bare, and the "seed," individual people stripped bare. The "seed" is planted in the "soil," where it sprouts, grows a stem, unfurls its leaves, and becomes a vast meadow.

But for some reason this meadow is unfamiliar. Though it is born from the "soil" and the "seed," it has become something completely different.

Thus I realize that, at this moment, what I can see before my eyes is not definite, but full of other possibilities. When I realize this, I feel a sensation of floating. It is at this moment that we are freed from our internalized rules.

Just now I talked of the individuality of people, and the individuality of land, but in actuality, is not this individuality just our own internalized rules?

This is what I felt when I first saw the Echigo-Tsumari Homestay Museum. Was it inevitable that one family should choose a carp hatchery as a means of making income after the Second World War? Was it also inevitable that 40 years ago the iron pot used for the popular Hokkaido dish "Jingisukhan" should be discarded and later used as a weight in the fields? Was it inevitable that a certain father's gateball medals should grow so numerous that they would hang like clusters of grapes around the house?

Upon close inspection, most things appear to be a mere random chain of events. People and land, appear to have a certain uniqueness, but upon retrospect, it seems to me that these aspects are walking a dangerous tightrope, just barely keeping their balance. They are like numberless seeds merging and diverging, by chance coming upon some recognizable form with the same happenstance that allows us to find shapes in the stars.

However, perhaps this isn't completely by accident. Somewhere, there has to be some connecting thread. Of course, this thread is not something that can be easily summed up in words. Its definition would, without a doubt, be quite long if one were to try. Most likely, things would become entangled, and one would just end up going around in circles.

Here as well, things can be divided into two philosophies. One side has us chasing this disjointedness that has scattered out into the far reaches of chance, while the other side has us trying to fasten everything together via "interpretation."

We build it up and knock it down, only to build it back up again. What arises from this is equivalent to reality. This random chance, reset via Fukasawa, is woven with an inarticulate story, creating a weave that is another reality.

It appears to me that, for Fukasawa, this is what it means to "create." This "creation" does not have a shape, and though it may appear so at first, it never commits to the community.

This is, unambiguously, his endeavor as an individual to taking his first steps away from his own internalized rules, via encounters with new people. If we share anything at all, would it not be the experience of taking that one breath of fresh air that we all subconsciously yearn for, even if it be only a single breath.

TAKAFUMI FUKASAWA'S ART METHOD

Fram Kitagawa
General Director, Echigo-Tsumari Art Triennale 2015

I have always thought of artists as a very strange type of people. They do things like stay at the home of a retired elderly gentleman. The gentleman, after retiring, has taken up folklore studies and straw crafts. These artists listen to their hosts, then create exhibitions about their findings. They take pictures of a certain house's alcove, decorated with an unearthed relic from the Jomon period, and add it to their exhibition. They take pictures of the 80 years old asparagus farmer living under the thatched roofing, implementing his unique way of harvesting, and add it to their exhibition.

Professional folklorists, like Tsuneichi Miyamoto, may have simply taken notes of their findings and returned home to record them properly. But artists prefer something different. They prefer to display their findings like works of art. Art is the act of exposing.

Since the Edo period, the people of the heavy snowfall region of Echigo-Tsumari have had a means of paddy farming called "segae," where the course of a winding river is changed to leave a marshy, lowland area that can be turned into a paddy. An artist staying at a different house heard that they raised carp in these paddies during the winter, so that the townsfolk wouldn't need to find work outside the village during the down season. It was also an artist who tried to portray the severity of mountain village work, the harshness of working outside the village during the off months, the precious money earned at the carp hatchery, and the terrible fate of the remaining 9,999 carp from every group of 10,000. The artist also found an unprecedented number of gateball awards, a cat door cut in a sliding door, a ghostly bottle gourd, and a jingisukhan pan used as a heavy weight, a remnant of the popularity of a certain kind of foods in the area some 40 years ago. These things were not found by the eyes of a folklorist. Artists more or less tend to focus on the little things of human existence. Artists do not approach things from the point of view of humans, or gods; and certainly not from that of social norms. Focusing on the little things means giving importance to the worlds of these individual lives and objects.

Looking at things this way, artists seem like a very different kind of person than folklorists, and in a certain sense, they are a bit cheeky; always trying to curry favor with others.

As I attempt to write about Takafumi Fukasawa, I find that I accidentally write about artists in general. However, artists like Fukasawa have become rare. He is truly an artist's artist.

How the Homestay Museum works can already be found on a different page, so I will omit repeating it here. However, I will mention here that our artist has done an immense amount of preliminary research, offered help and support to the volunteer researchers,

guided tours, and managed the museum. A total of 30 researchers have surveyed 12 different houses. This is quite a number. Our artist takes what could be considered a holistic approach, engaging in all aspects of the project; even creating models for the exhibition. Actually, Fukasawa was always a large presence during the Echigo-Tsumari Art Triennale period. In the essay "A Museum for the Average Person" he gives a clear and understandable explanation of the Museum's details and goals, and his thoughts on the project.

I first learned about Fukasawa in the summer after the 2011 Tohoku Earthquake. It was when he was helping out at a camping school for children from the Tohoku and urban areas. He had come as one of the artists who worked with Tsuyoshi Ozawa's "Kamaboko Art Center," which had been held in the Matsudai area. After the camp had finished, I heard from the staff that he kept the kids entertained with teamwork building games after they had been shut up inside for an entire day due to heavy rain. At that moment the name "Fukasawa" became forever engraved in my mind as a genius of entertainment, an artist's artist, someone worthy of my respect. In our modern age where everything is hard and obsessed with being "equal," where it seems like nothing can get done without an explicit user's guide, people like Fukasawa are vital. The reason why artists are so wonderful is precisely because they fulfill such a role. It is my opinion that it is exactly because such an artist has come to the region that art of the 21st century, the art of the connectivity of humans and nature, humans and civilization, can come into existence.

The Homestay Museum is, itself, an act of moving deeper into the snowy and mountainous Echigo-Tsumari region, the act of clarifying the bonds we create with nature when we inhabit a certain area for a long period of time, and the act of connecting the local people with new visitors to the area. I feel that this is the kind of art we have been searching for. I am keeping a close eye on Fukasawa. We may very well be witnessing the birth of an artist of this new generation.

普通の人の博物館

　越後妻有の一般家庭のお宅に民泊させてもらおうと思いついた。民泊した人がそこでの暮らしぶりを伺いそれを記録する。さらにその記録を民俗資料として中心市街地に集め現代の民俗博物館をつくっていく。民俗学が専門でもないのに民俗博物館をつくり、民泊調査といって地域の人にもたくさんのお力添えをいただく。このような二重に畏れ多い企画を考案したのは2014年の12月だった。民泊と民俗博物館、ふたつの意味が重なってタイトルは「越後妻有民俗泊物館」となった。

　リサーチに入るまで知らなかったのだが、1999年頃からこの地域は田舎体験という名称で子どもの民泊の受け入れを続けており、行政や住民の受け入れの基礎はすでに出来上がっていた。しかし近年、受け入れ先の高齢化などの理由により、少しずつ縮小し始めてもいるのが現状だ。

　2015年、大地の芸術祭の出品作品は、400点近い作品数になった。スタンプラリーで慌ただしく作品を回るだけではなく、限られた時間のなかでも、特有の暮らしぶりを体験・追体験できるようなものにしたいと思った。また中心市街地プロジェクトで招聘していただいたのがきっかけということもあり、中心市街地の役割についても考えたかった。越後妻有と一言でいっても、十日町市と津南町のふたつの市町からなる地域であり、十日町市にしても2005年に5つの市町村が合併してできた市で、内包する集落は400を超える。十日町市の中心市街地はこの地域の経済の中心となっているが、それだけではなく、市街地と集落の文化的なハブ機能をつくることで中心の意味合いを捉え直してみたいと思った。中心市街地から出発してさまざまな集落へと旅立っていき、それらが戻って集積されていく場所をつくる。中心と周辺の関係を見つめ直していくことは、十日町に限らずあらゆる都市に共通する問題なのではないかと思った。

　「越後妻有民俗泊物館」は、ただものを陳列することで民俗文化や風習をみせるのではなく、個人を切り口にした暮らしの営みを資料として集めることにした。あえて個人に焦点をあてていくことで、集落や家を存続させることを生活の軸にしていたこの土地特有の近代化が見えたように思う。

　このお宅では、梁の上になぜ油絵をかかげているのか。どうして縄文土器を鍬で割ったのか。なぜ油揚げをつくっていた人が押し花作家になるのか。集落で災害が起きても自分たちで復興してしまえるのはなぜだ。この方はどうしてちゃんこ鍋をこんなにも美味しくつくれるのか。どれもこれも本当に個人的な話からははじまるのだが、掘り下げていくとどれも土地の特性と歴史と結びついていくものばかりだ。

　越後妻有においてもっとも印象深い体験は、ここでの生活そのものだ。そこには無理に加工する必要のない、そのままでも多くの現代人に届くものやエピソードがつまっていた。ここで暮らす人々は近代的な個人として単純にわりきれるものではなく、人一人に対して、家、土地、集落などいろいろな要素が地続きになって表れてきた。

　単純に郷愁に浸るものではなく、脈々と続いてきた土地との関わり方と、地域の土木力に顕著に表れている近代化により、いかにここの営みが変わっていったかの両面がないまぜに

なったものを集めていった。私たちが戦後切り離していった土地とともに生きる暮らしと、地域の近代化とが混合して、おそらくそこには意図してできたものではないハイブリッドな豊かさと力強さがあるように思えた。それはわりきれない個人のありようで、村社会的なものが他者に開かれたときに、なにか新しい可能性にも感じられた。

「越後妻有民俗泊物館」には、私が集めたものだけでなく、研究員を募集し、会期中その人たちに民泊をしてもらい彼らの視点で資料を集めてもらった。

要するに、「普通の人が普通の人のお宅に泊まらせてもらってお話しを聞く」という当たり前のことが、このちょっと変わった博物館の実態であり肝でもある。同じ日本で同じ日本人だったとしても、"同じ"ということの方が実はフィクションだということに気づかされる。「越後妻有民俗泊物館」は失われながらも、変わり続けているこの地域の暮らしの現在地点を、住む人の視点と他者の視点の偶然の交差が繰り返され、見続け、見せ続けていく。たとえば10年続け、ここに時間軸が足されるとどんな場所になるのだろう。質量をともなわない情報としてのコミュニティに生きることに慣れ、日々「普通であること」の定義が変わり続ける現代で、この場所の意味も変わっていくのではないだろうか。

2016年4月　深澤孝史

A MUSEUM FOR THE AVERAGE PERSON

I had an idea where researchers would stay with local people in the Echigo-Tsumari region, and then create an exhibit based on the stories they heard during their stay. The researchers would bring various objects from their homestays to the center of town, creating what is now known as the Homestay Museum.

I am very grateful for the opportunity to establish this museum, despite the fact that I do not have a background in folk studies. A lot of the research I did in the area was made possible thanks to help from the local people. I first suggested this terrific (in both senses of the word) project back in December 2014. As it is both a homestay and a folk culture museum, it came to be called the Homestay Museum.

While I was not aware of it until I first started doing research for the museum, the area has already had a homestay program that allowed children to stay with local families and experience farm life since 1999. This meant that there was already a precedent for the kind of program I wanted to start. Moreover, due to many of the younger generation moving out of the area, the original program itself had begun to shrink.

In 2015, the Echigo-Tsumari Art Triennial featured nearly 400 works of art. Considering that visitors were very busy visiting each of the various works, I was eager for them to experience local lives even if it was for only a limited amount of time. As it was also the Tokamachi City Center Project that invited me to the festival, I wanted to think about what I could do for the project. What is often referred to as the Echigo-Tsumari region actually consists of Tokamachi City and Tunan Town, containing over 500 villages. Tokamachi City itself was created by combining five different municipalities in 2005. I was hoping to reshape the meaning of city center from a strictly economic one to one that encompasses the culture of the area as well. I wanted to make a place from which people will depart and take back their experiences with them after traveling to the various villages in the region. Furthermore, I think this kind of facility would not just benefit Tokamachi, but other areas as well.

The Homestay Museum is not simply a place for displaying objects and showing the culture of the region, but a meeting place for those who have traveled around the surrounding area. By focusing on the individual, I believe we can gain a better view of the way the area is changing over time as the local people try to maintain and ensure the survival of their homes and villages.

Each of the homes has its own individual stories. Why is it that one house decorates its ceiling beams with oil paintings; or what was the reason for the local people to smash the unearthed Jomon pottery? Why did a home of *abura age*

makers begin pressing flowers? How was it that the villagers were able to restore their homes after their village was hit by the earthquake? And what makes that person's *chanko nabe* so incredibly delicious? The more we dig, the greater we see the connections between the land and its history.

The experiences that left the deepest impression of the area were of the daily life itself. Unfettered, these local lives naturally relate their many background stories.

Even as modern individuals, we see these lives not as discrete units, but are able to understand them as a continuous flow of different elements - the family, the land, and the community - rather than identify the people simply as modern individuals.

Our objects, which were not collected from a nostalgic point of view, show how the local people have continued to interact with the land to the present day and also the changes in wealth due to modernization, which is most noticeable in the local civil engineering.

In this region, I have discovered a hybrid richness and strength brought about by an unintentional mixing of local lives rooted in the land, which were divorced from one another after the War, and local modernization. The local people reflect the nature of individuals who cannot be distinguished from village communities, but if the communities were opened up to the outsiders, new possibilities might emerge.

The displays at the museum are not just arranged by myself, but by our researchers, who choose objects from their homestays based on their own personalities and experiences. In essence, the core of the museum is that it is created from the stories of everyday people, gathered by everyday people in the most natural ways possible. We notice that even though these people are all the "same Japanese" from the "same Japan," it is actually a fiction to see them as the "same."

I would like the Homestay Museum to continue to be a meeting place for the viewpoints of visitors and those living in this continually changing region. I wonder what would become of the museum if we were able to continue for another 10 years. In this age where we have become used to communication as insubstantial information, and the definition of being "average" is always changing. In a similar way, I suppose the meaning of the Homestay Museum will also eventually change.

<div style="text-align: right;">
April, 2016

Takafumi Fukasawa
</div>

深澤 孝史　略歴

美術家。1984 年山梨県生まれ。リサーチを元に地域や場のもつ可能性に言及するプロジェクト型のアートワークを多数手がける。2011 年よりお金のかわりに自身のとくいなことを運用する《とくいの銀行》(取手アートプロジェクト) を開始。2012 年に浜松の中心市街地にて、さまざまな場や活動を障害物にしたイベント「しょうがいぶつマラソン 2012」（浜松）を企画。また、越後妻有大地の芸術祭 2012 にて、非常事態を表現活動に翻訳する「非常美術倉庫」を制作。2013 年、山口情報芸術センター 10 周年記念祭にて、とくいの銀行を運営しつつ、架空の商店街のまちづくりを演劇的に行った《とくいの銀行 山口》。2014 年、発達のゆるやかな幼児の通所施設「根洗学園」で行ったプログラムの展覧会「おべんとう画用紙」、土で現像する写真スタジオ《photoground》（めぐるりアート静岡、2014）、札幌国際芸術祭 2014 にて札幌開拓史と現代のとくいを結びつける《とくいの銀行 札幌》を制作。

個展
2010　　「うんこふみふみたかふみ文化センター」たけし文化センター arsnova（浜松市）

主な展覧会
2015　　「第 6 回大地の芸術祭 越後妻有アートトリエンナーレ 2015」（十日町市・津南町）
2014　　「富士の山ビエンナーレ」（富士市）
2014　　「札幌国際芸術祭 2014」（札幌市）
2014　　「めぐるりアート静岡」（静岡市）
2013　　「山口情報芸術センター［YCAM］10 周年記念祭『LIFE by Media 国際コンペティション』」（山口市）
2012　　「第 5 回大地の芸術祭 越後妻有アートトリエンナーレ 2012」（十日町・津南町）
2007　　「W あつしの大運動会」BankART（横浜市）
2007　　「深澤孝史／高杉悦生二人展」Gallery sensenci（静岡市）
2006　　「取手アートプロジェクト 2006」取手市福祉会館（取手市）
2006　　「身体アート展」ギャラリー CAVE（浜松市）

プロジェクト
2014 -　「おべんとう画用紙」静岡文化芸術大学ギャラリー（浜松市）
2012　　「しょうがいぶつマラソン」（浜松市中心市街地）
2011-　 「取手アートプロジェクト『とくいの銀行 井野本店』」いこいーの＋ TAPPINO（取手市）
2011　　「かがやきキラキラ仕事館」浜松市発達医療センター（浜松市）

TAKAFUMI FUKASAWA
BIOGRAPHY

Artist

1984 Born in Yamanashi Prefecture, Japan
2006 Graduated from Shizuoka University (B.A.)

SOLO EXHIBITIONS
2010 "Unkofumifumitakafumi Culture Center," Takeshi Culture Center, Hamamatsu City

SELECTED EXHIBITIONS
2015 "Echigo-Tsumari Art Triennale 2015," Tokamachi City + Tsunan Town
2014 "Fujinoyama Biennale," Fuji City
2014 "Sapporo International Art Festival," Sapporo City
2014 "Megururi Art," Shizuoka City
2013 "YCAM 10th Aniversary LIFE by MEDIA," Yamaguchi City
2012 "Echigo-Tsumari Art Triennale 2012," Tokamachi City + Tsunan Town
2007 "The joint exhibition of Fukasawa and Takasugi," Gallery sensenci, Shizuoka City
2006 "Toride Art Project 2006," Toride City
2006 "Physical Art," Gallery CAVE, Hamamatsu City

PROJECTS
2014 "Lunch Box Paper," Shizuoka University of Art and Culture, Hamamatsu City
2012 "Obstacle Marathon 2012," Hamamatsu city Museum of Art, Hamamatsu City
2011- "Tokuino Bank," Toride Art Project, Toride City
2011 "Kagayaki Work Center," Hamamatsu Social Welfare Community Center, Hamamatsu City

越後妻有民俗泊物館
開催概要

会期
2015年7月26日（日）〜9月13日（日）

会場
十日町産業文化発信館 いこて 2階
新潟県十日町市本町5丁目39-6

2015年度民泊調査は4月〜9月にかけて実施し、全13回12軒の家に30人のみんぱく研究員が参加した。各調査のレポート全文は下記のウェブサイトにて公開中。

公式ウェブサイト
www.homestaymuseum.net

2016年4月28日（木）より再オープン
場所：越後妻有里山現代美術館 [キナーレ]

謝辞
本プロジェクトの開催にあたって、下記の皆様より多大なるご協力を賜りました。ここに記し、深く感謝の意を表します。
（敬称略・順不同）

越後妻有民俗泊物館 館長　深澤 孝史

みんぱく研究員
藤倉 晴／安藤 僚子／田中 みゆき／藤谷 けい／伊藤 洋志／塚本 聡子／甲元 理子／白川 みどり／白川 泉／免田 るか／村山 さつき／長津 結一郎／石橋 鼓太郎／太田 祐輝／西岡 真由美／山中 みほ／太田 清美／笹田 夕美子／乾 久子／乾 大地／小田 弥生／藤田 美緒／東 祐輔／中田 一会／黒部 順子／島田 一宏

民泊受け入れ先のご家族
石澤 今朝松／石澤 ヒサ／江口 通博／江口 キヨノ／江口 克子／草村 慶子／草村 茂／樋口 守雄／関口 美智江／五十嵐 茂義／五十嵐 江美子／柳 能弘／柳 ハルエ／門脇 洋子／福崎 一久／福崎 陸子／福崎 英一／福崎 カン／福崎 平八郎／福崎 キヨノ／福崎 勝幸／福崎 由希子／福崎 進／福崎 美恵子

協力
木暮 茂夫／桑原 光江／滝沢 正彦／樋口 道子／田中 一男／江口 幸子／三浦 玄也／尾身 真弓／涌井 実／青木淳建築計画事務所 十日町分室「ブンシツ」／株式会社フラワーホーム／こへび隊のみなさん

管理運営
山口 祥平（第6回大地の芸術祭 越後妻有アートトリエンナーレ十日町市街地プロジェクトディレクター）／大木 彩子（大地の芸術祭 実行委員会事務局）／島雄 豊（大地の芸術祭 実行委員会事務局）

会場設計施工
鈴木 雄介／櫻井 駿介／村田 萌菜／Léo Allègre／吉田 尚弘／松岡 未来／横井 かな

会場サイン／ウェブデザイン
井出 はるか

運営スタッフ
佐野 翔／石山 律／田中 保帆／永井 雅人／猪熊 梨恵

ECHIGO-TSUMARI HOMESTAY MUSEUM OVERVIEW

DATES
26 July - 13 September, 2015

VENUE
Tokamachi Industry and Crafts Center "Ikote"
3-39-5, Honcho Tokamachi city, Nigata Prefecture, Japan

HOMESTAY RESEARCH
Dates: April through September, 2015
Number of research studies: 13
Number of researched houses: 12
Number of researchers: 30
*Detailed reports are uploaded on the official website.

DIRECTOR
Takafumi Fukasawa

RESEARCHERS
Haru Fujikura / Ryoko Ando / Miyuki Tanaka / Kei Fujiya / Hirosi Ito / Satoko Tukamoto / Riko Komoto / Midori Shirakawa / Izumi Shirakawa / Ruka Menda / Satsuki Murayama / Yuichiro Nagatsu / Kotaro Ishibashi / Yuki Ota / Mayumi Nishioka / Miho Yamanaka / Kiyomi Ota / Yumiko Sasada / Hisako Inui / Daichi Inui / Yayoi Oda / Mio Fujita / Yusuke HIgashi / Kazue Nakata / Junko Kurobe / Kazuhiro Shimada

HOST FAMILIES
Kesamatsu Ishizawa / Hisa Ishizawa / Michihiro Eguchi / Kiyono Eguchi / Katsuko Eguchi / Keiko Soumura / Shigeru Soumura / Morio Higuchi / Michie Sekiguchi / Shigeyoshi Igarashi / Emiko Igarashi / Yoshihiro Yanagi / Harue Yanagi / Yoko Kadowaki / Kazuhisa Fukuzaki / Mutsuko Fukuzaki / Eiichi Fukuzaki / Kan Fukuzaki / Heihachiro Fukuzaki / Kiyono Fukuzaki / Katsuyuki Fukuzaki / Yukiko Fukuzaki / Susumu Fukuzaki / Mieko Fukuzaki

IN COOPERATION WITH
Shigeo Kogure / Mitsue Kuwabara / Masahiko Takizawa / Michiko Higuchi / Kazuo Tanaka / Sachiko Eguchi / Genya Miura / Mayumi Omi / Minoru Wakui / Jun Aoki & Associates Tokamachi Office / Flower Home Co., Ltd. / The Kohebi supporters

MANAGEMENT
Shohei Yamaguchi (Director, Tokamachi City Center Project, Echigo-Tsumari Art Triennale 2015)
Ayako Oki, Yutaka Shimao (Echigo-Tsumari Art Triennale 2015 Secretariat)

SPACE DESIGN & INSTALATION
Yusuke Suzuki / Shunsuke Sakurai / Moena Murata / Léo Allègre / Naohiro Yoshida / Miku Matsuoka / Kana Yokoi

SIGN DESIGN & WEB DESIGN
Haruka Ide

STAFF
Sho Sano / Ritsu Ishiyama / Yasuho Tanaka / Masato Nagai / Rie Inokuma

Echigo-Tsumari Homestay Museum is to be reopened at the Echigo-Tsumari Satoyama Museum of Contemporary Art "KINARE" on April 28, 2016.

OFFICIAL WEBSITE
www.homestaymuseum.net

越後妻有民俗泊物館
深澤 孝史

2016 年 4 月 28 日発行 初版第一刷

編著
深澤 孝史

デザイン・編集
井出 はるか

編集
前田 礼（現代企画室）
小倉 裕介（現代企画室）

翻訳
中野 テイラー
株式会社リングァ・ギルド

発行者
北川 フラム

発行
現代企画室
〒150-0031 東京都渋谷区桜丘町 15-8 高木ビル 204
Tel: 03-3461-5082
Fax: 03-3461-5083
Email: gendai@jca.apc.org
http://www.jca.apc.org/gendai/

印刷
株式会社グラフィック

著作権上の例外を除き、本書の全部または一部を無断で複写複製（コピー）することは法律で禁じられています。

ISBN 978-4-7738-1605-1 C0070 Y1800E
©Takafumi Fukasawa 2016, Printed in Japan

ECHIGO-TSUMARI HOMESTAY MUSEUM
TAKAFUMI FUKASAWA

Date of Publication: 28 April, 2016

Author / Editor:
Takafumi Fukasawa

Designed and Edited by:
Haruka Ide

Edited by:
Takafumi Fukasawa
Rei Maeda [Gendaikikakushitsu Publishers]
Yusuke Ogura [Gendaikikakushitsu Publishers]

Translated by:
Taylor Nakano
Lingua Guild, Inc.

Publisher:
Fram Kitagawa

Published by:
Gendaikikakushitsu Publishers
Takagi Bldg. 204, 15-8 Sakuragaoka-cho, Shibuya-ku,
Tokyo, 150-0031, Japan
Tel: 03-3461-5082
Fax: 03-3461-5083
Email: gendai@jca.apc.org
http://www.jca.apc.org/gendai/

Printed by:
Graphic Co., Ltd

No part of this publication may be reproduced, without the prior permission of the Publisher.